ICONS

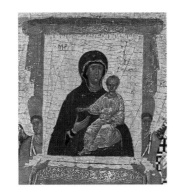

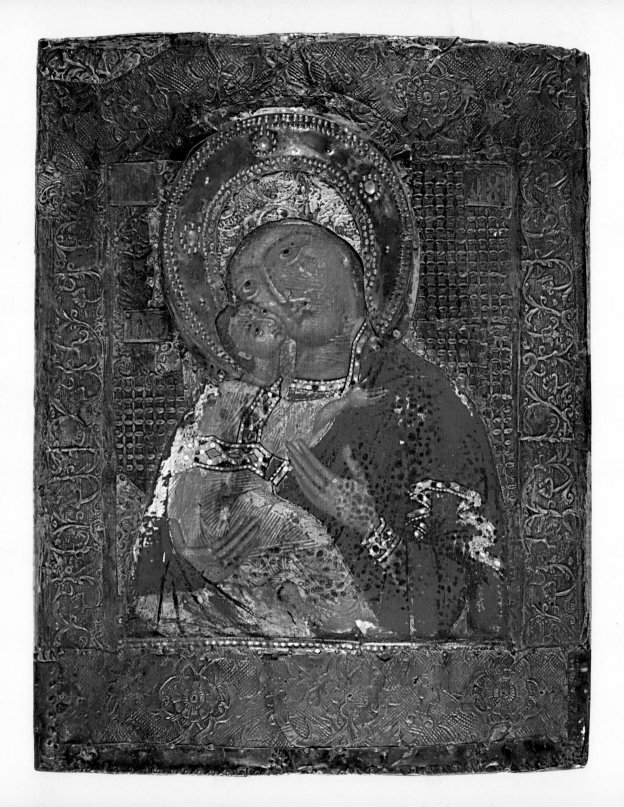

ICONS

Robin Cormack

THE BRITISH MUSEUM PRESS

First published in 2007 by The British Museum Press
A division of The British Museum Company Ltd
38 Russell Square, London WC1B 3QQ

www.britishmuseum.co.uk

A catalogue record for this book is available from the British Library

ISBN-13: 978-0-7141-2655-5

ISBN-10: 0-7141-2655-1

Designed and typeset in Didot, Joanna and Thesans by Price Watkins

Printed in China by C&C Offset Printing Co., Ltd

Half-title page: Icon with the Triumph of Orthodoxy; detail showing
the representation of the miraculous icon of the Virgin Hodegetria. Byzantine
(Constantinople), *c.* 1400. 39 x 31 cm (whole object). British Museum.

Frontispiece: Icon with the Mother of God Vladimirskaya. Russian,
seventeenth century. 31.4 x 25.1 cm. British Museum.

Contents

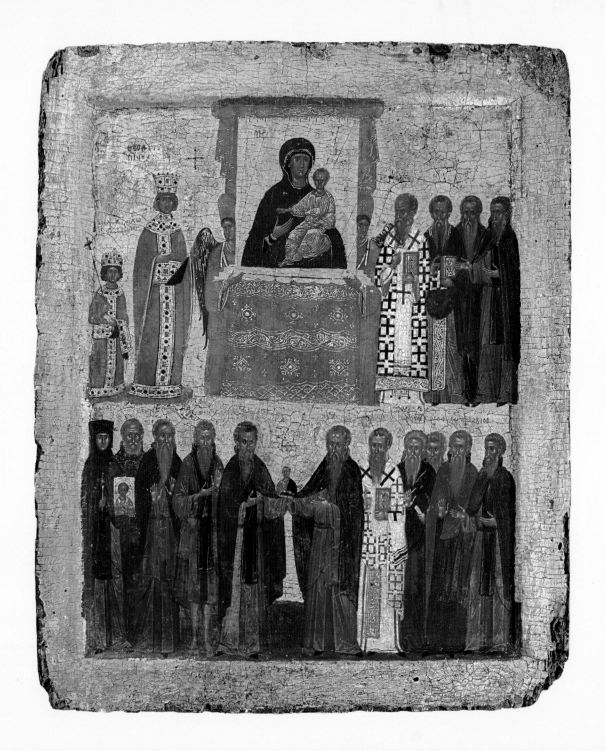

Icons and iconoclasm
The power of images

I t is sometimes said that the only place really to experience icons is inside a church or monastery, where they have an active presence and help to create the mystique of a sacred place. Visitors to the remote monastery of St Catherine's at Sinai in Egypt (fig. 2), constructed around the site of the Burning Bush and below the mountain where Moses is said to have received the Law, may indeed feel that they have arrived at the only place on earth where pilgrims and monks have maintained Christian services surrounded by icons since the middle of the sixth century. But the truth is that, while a museum and a church are profoundly different places in which to view works of art, each has its own advantages. The visitor to a museum collection of icons can look at every detail for hours and has the advantage of the information and lighting which only that environment can offer. In the case of the British Museum, which holds a collection of 100 icons, it is the only place in the United Kingdom where major examples can be seen and appreciated. The aim of this book is to provide some information for understanding the history of icons and to show how examples in the British Museum's collection can illuminate many aspects of the production and power of this distinctive art form.

What is an icon? (fig. 3) 'Icon' must be today the most overused word in the English language, evoking anything from a charismatic film star or footballer to Leonardo's *Mona Lisa*. The word comes from the Greek *eikon*, which means a 'likeness, image or picture'. In the Middle Ages a 'holy' *eikon* meant an image used for Christian purposes, a portrait icon of a saint, for example, providing a focus for the veneration and reverence

1. Icon with the Triumph of Orthodoxy

Byzantine (Constantinople), c. 1400. 39 x 31 cm
British Museum

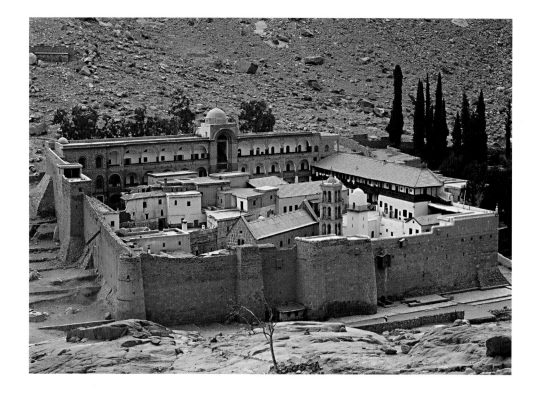

2. The monastery of St Catherine at Sinai, Egypt

The fortified monastery was built in the reign of the Emperor Justinian between 548 and 565 at the site of the Burning Bush and below the mountain where Moses received the Law. The main church of the sixth century, with its nineteenth-century bell tower, is in the foreground.

of personalities who offered models for the best Christian life. In this book 'icon' will in the main refer to the paintings on wood panels made for public use in the rituals and decoration of the Byzantine and Orthodox church and for private devotions and prayers at home. This means that it was (and still is) a form of art which both promotes and supports Christian faith and worship, and which communicates the ways in which believers may understand their world. Some say that icons are the most effective type of religious art so far developed and that viewers appreciate the power of peaceful and clear imagery. Icons are never overstated pictorially, but equally they are never simple in their messages.

The painted panels in the spotlight here are nowadays seen as the typical form of the icon. However, as the Greek word suggests, a icon could be made from ivory, enamel or any other media in which Orthodox artists excelled, including miniature mosaics, which became extremely popular in the fourteenth century; an example is the Annunciation in the Victoria and Albert Museum (see fig. 34). For this reason, a few icons in these media will also appear in these pages. Byzantine viewers may well have preferred their icons in more exotic materials than mere flat painted panels; from the twelfth century onwards, for example, it became fashionable to add precious-metal overlays to icons, while in later Russian icons covering all but the faces of figures becomes commonplace (fig. 4).

BACK TO THE BEGINNING

In the first centuries of Christianity there are a few scattered (and perhaps sometimes fanciful) references to icons, but no real evidence of their production in any numbers. Figurative art in the Christian religion only began in earnest in the third century, but from the fourth century onwards icons became more and more part of the everyday life of the faithful. What is difficult for us to understand today is what thoughts went through the minds of the first viewers of these early icons. The common experience of this audience also involved the veneration of martyrs' bodies and relics and various objects connected with the Virgin Mary and Christ, such as her garments or the cross on which he was crucified (reputedly discovered in the fourth century in Jerusalem at the site of Golgotha by Helena, the mother of Constantine, the first Roman emperor to be baptized as a Christian). Did they think that the immortal souls of the saints, or even that of the Virgin, were somehow inside the icon? Or was the image rather a memento of the saints' lives on earth, before they entered paradise at the moment of death? This was as much a controversial question for the early Christians as it is for us, and Byzantine theologians continued to debate the nature of art and the issue of idolatry while the production of icons accelerated. This long period of dialogue ended around the year 730, when a powerful emperor at Constantinople, Leo III, totally banned the production and use of icons in churches and, following this decision, instigated the Council of Constantinople of 754, which made iconoclasm the official dogma of the Orthodox church. This aggressive period of iconoclasm lasted for over a century in all, but there was a break from 780 to 813, during which the Council of Nicaea of 787 reinstated the use of icons. Byzantine iconoclasm was finally crushed in 843 when the church declared that to attack icons was heresy. Our knowledge of the Byzantine iconoclasts comes primarily not from their writings, but from those of the victors in the debate, the iconophiles. The iconophiles pilloried the iconoclasts as heretics, and as evil as the Roman soldiers who crucified Christ. In the Khludov Psalter of the ninth century (fig. 5), the pictorial analogy between the iconoclasts who whitewashed paintings and the soldiers who tormented Christ is a very powerful image in its own right.

The failure of iconoclasm was described in subsequent Byzantine history as the Triumph of Orthodoxy and the year 843 marked the firm establishment of the use of icons within the ritual and devotional practices of the Orthodox church. From this time onwards icons were a key element in giving an identity to the Orthodox church, leading to their ubiquitous presence in the church, the street and the home, conspicuously in the Byzantine and Slavonic Orthodox worlds.

3. 'I'm an Icon . . .'

Cartoon by Tom Lubbock. 1991. 24.5 x 22.5 cm

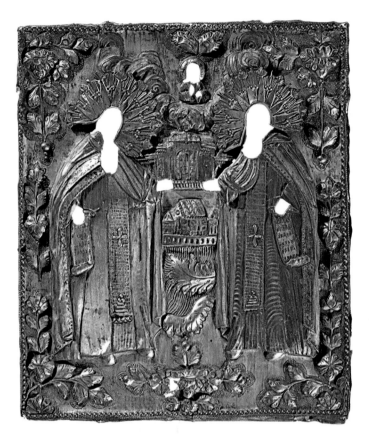

4. Oklad of icon with Sts Zosima and Savvatiy (founders of the Solovetsky monastery on the White Sea) holding a model of a church

Northern Russian, second half of the eighteenth century. 31 x 26.3 cm British Museum

Considering the circumstances of iconoclasm can help us to explore the meaning and importance of icons. The period was one of the major turning points in Christian thinking about the nature of art and the idea of the Holy. The enduring memory of iconoclasm is highlighted by a major icon in the British Museum (fig. 1). Painted in the fourteenth century, it is the earliest known icon to represent the Triumph of Orthodoxy, declared in 843. This panel was most likely made to be displayed annually in a church on the anniversary of the defeat of iconoclasm, which was from 843 onwards celebrated with a special service on the first Sunday in Lent. At that service the names of Orthodox heroes were read out, along with a definitive list of Orthodox doctrines known as the Synodikon of Orthodoxy, and the icon would have been kissed with reverence by those in attendance. Although this icon was painted centuries later than the first celebration on 11 March 843 – its style points to the second half of the fourteenth century and its quality and style to Constantinople as its place of production – its viewers only would have been able to appreciate fully the imagery of the icon if they could recognize and meditate on the key figures who participated in the defence of icons during the events of the eighth and ninth centuries. Such a meditation would have taken place within the context of the fourteenth century, the time the icon was painted, when a considerable tradition had grown around the history and end of iconoclasm. By this date there were texts which suggested that the first celebration involved a public liturgical procession through the streets of Constantinople, the participants carrying icons and crosses; starting at the church of the Virgin at Blachernai, it included a service in St Sophia and a final procession to the imperial Great Palace, entering through the Chalke Gate.

The viewer of the Triumph of Orthodoxy icon was also helped by the inclusion of a name, written in red letters in Greek, beside each figure. It was a recurrent feature of icons to give names, combining often stereotyped imagery with clearly signified identities. It is a matter of modern debate to ask why writing was considered such an integral part of the pictorial icon, particularly in a society where less than ten per cent of the population was literate. Not all the names on this icon are still legible today, as they are abraded and the paint has rubbed off.

At the top left of the icon is the Empress Theodora who was in power in 843 as regent to her infant son, Michael III, born in 840 and shown here as somewhat more regal than the average three year old. At top right is a figure wearing a black and white cross-covered *sakkos*, the Greek equivalent of the Latin *dalmatic*, originally the exclusive ceremonial dress of the Patriarch but by the fourteenth century worn by bishops as well. This saint is Methodios, the newly appointed Patriarch of the Orthodox church in 843 and a faithful iconophile whose jaw was said to have been broken as an imperial punishment for his intransigence during iconoclasm. Several famous iconophile martyrs and heroes are shown in the row of saints below. The two at the centre, probably Theophanes the Confessor of Megas Agros (c. 760–817) and Theodore the Studite (759–826), hold between them an icon of the young Christ Emmanuel (fig. 6). This icon originally may have been circular in format, according to an examination undertaken in 1984, but the evidence is not clear today. At the left a nun holds a small portable icon, also of Christ Emmanuel. Its red picture hook is just visible at the top. The inscription identifies this nun as St Theodosia, a somewhat shadowy figure around whose name an increasingly popular cult developed in Constantinople. She was supposedly martyred by the imperial soldiers at the outbreak of iconoclasm when she led a group of women to prevent an icon of Christ at the Chalke Gate entrance to the Great Palace from being

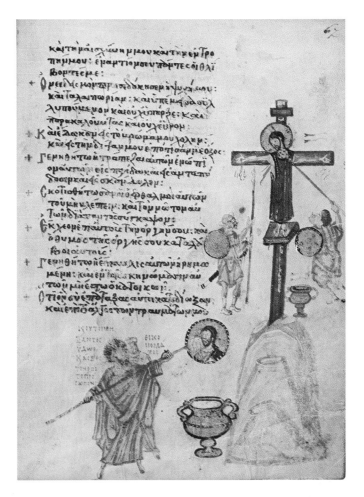

5. Khludov Psalter, folio 67r

Constantinople, ninth century (after 843). 19.5 x 15 cm
State Historical Museum, Moscow

This manuscript page depicts the Crucifixion alongside iconoclasts whitewashing an icon of Christ. It illustrates the Septuagint Psalm 68:22: 'They also gave me gall for my food, And for my thirst they gave me vinegar to drink.'

destroyed. Actually it seems likely that this violent event and her presence at it was a pious fiction, but the story was increasingly embroidered over the centuries. Her name even features in the history of the end of the Byzantine empire, for 29 May 1453, the day that Constantinople fell, happened to be her festival day, and the congregation worshipping in the church of St Theodosia was massacred by the invading Ottoman troops. Other saints are identifiable on the icon, such as Ioannikios (fourth figure from left), the brothers Theodore Graptoi (so-named because in 836 the Emperor Theophilos ordered twelve iambic lines of iconophile poetry to be tattooed on their foreheads), Theophylactos and Arsakios (far right). These are historical churchmen who were thought to have taken part in iconoclasm or the final events of 843, though Arsakios was only linked with them in a fourteenth-century text of the *Life of Empress Theodora*.

6. Detail of the icon with the Triumph of Orthodoxy (fig. 1)

The nun, St Theodosia, is holding the icon of the young Christ from the Chalke Gate of the Great Palace of the Byzantine emperors at Constantinople, which she tried to save from iconoclasts. The names of the two iconophile monks with her are no longer readable.

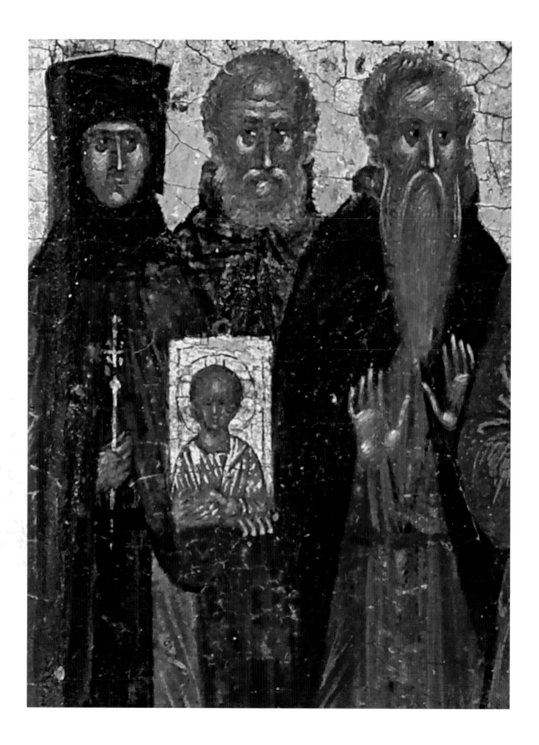

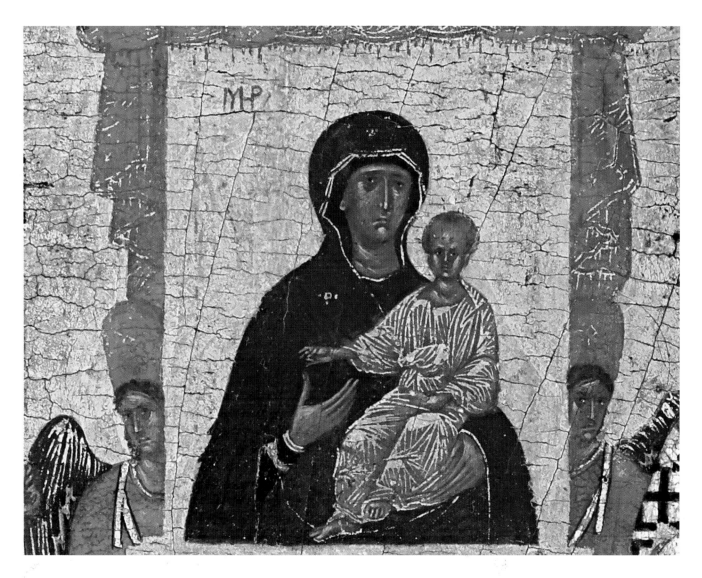

The Triumph of Orthodoxy was always a rare subject for icons; less than a dozen examples are known in all. The next known example of the subject chronologically (around a hundred years later) is a direct copy of the British Museum icon, which suggests the limited currency of the subject. This Triumph of Orthodoxy icon is now in the Velimezis Collection in Athens (fig. 8). It is roughly the same size as the British Museum version but the painting is much rougher and cruder. Visually the impact of both icons works at several levels. At first sight they might seem simply to be putting on display the

7. Detail of the icon with the Triumph of Orthodoxy (fig. 1)

This detail shows the representation of the miraculous icon of the Virgin Hodegetria, supposedly painted from life by the evangelist St Luke.

iconophile champions of the eighth and ninth centuries, as well as including representations of a number of important icons. But the combination of figures and objects evokes more than just these functions. The prominent positions in the upper register of the Empress Theodora and Patriarch Methodios, who between them engineered the official declaration that iconoclasm was a heresy, make a point about the nature of authority and power in Byzantium. The emphasis on monks and churchmen in the lower register correspondingly communicates the idea of their importance in Orthodox history, owing to their resistance to the imperial policy of iconoclasm.

Perhaps the most evocative and emotional imagery is at the centre of the upper register. What we see here is a second icon represented within the frame of the Triumph of Orthodoxy icon. In a sense this is the key image, the subject almost, of the Triumph of Orthodoxy. It is a large icon of the Virgin Mary and Child or, as the Byzantines would have said, the *Panagia* ('All-Holy One') or Mother of God (fig. 7). This icon is represented on a base with a decorated red cover; red curtains on each side are pulled back so that it is fully open to view and no longer veiled from sight (as any surviving icons must have been during iconoclasm). The icon is safely held by two men with red garments and tall hats who grip its base. These men are most likely the guardians of the icon in the place where it was kept, though they have wings, the meaning of which is hard to interpret. Like the Virgin in the icon that they display, they look out towards the viewer, and the gesture of their hands almost exactly mirrors hers. In discussions of this icon these men have been described as 'angel-deacons'.

The large and heavy icon held by the men is not a generic image but a well-known panel in Byzantine history. It was entitled the *Hodegetria* icon, the name referring to the gesture of the Virgin, who is pointing towards her son. The word is frequently translated as 'She who shows the way [to God]', but the visual references in the iconography are no doubt manifold. For example, the Virgin's expression in Hodegetria icons is often described as pensive and sad, and accordingly seen to predict Christ's crucifixion. It is also relevant that in the Middle Ages this icon was kept at the Hodegon monastery in Constantinople. This complex included a miraculous well where the blind and those with eye disorders were led in the hope of being healed by its water; the *Hodigoi* were the guides who led them there. The word *Hodegetria* may therefore refer to this aspect of the monastery, or to the notion of the Virgin as a guide.

The Hodegetria icon is prominent in the Triumph of Orthodoxy for a good reason, to which the key lies in the reputed history of the panel as believed in Byzantium. The Byzantines supposed that the very first Hodegetria icon was painted from life by the evangelist St Luke at the time of the birth of Christ (fig. 9). This story that St Luke was an artist as well as a Gospel writer was most likely a creation of the iconophiles (it first appears in the writings of Andrew of Crete; 660–740) and it was a landmark argument in favour of the idea that icons were legitimate from the moment of the incarnation of

8. Icon with the Triumph of Orthodoxy

Cretan, c. 1500.
36.4 x 31 cm
Velimezis Icons
Collection, Athens

This icon is a copy of
the British Museum
version (fig. 1).

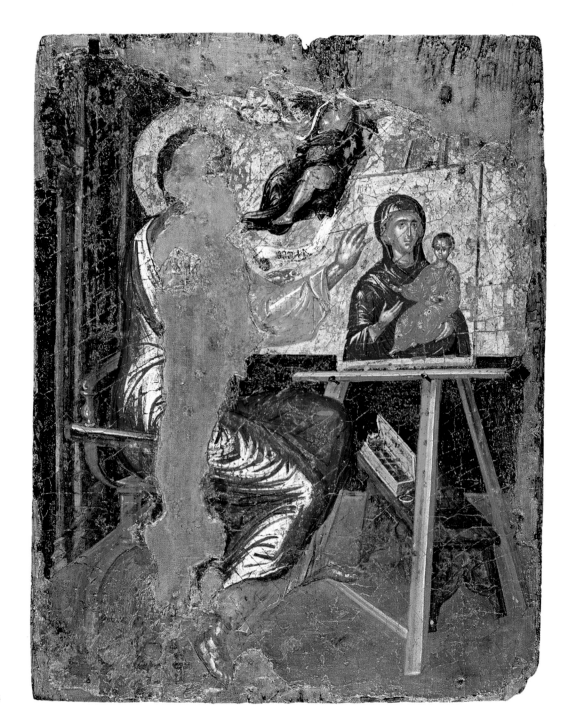

9. 'St Luke painting the Virgin and Child' by El Greco

Signed 'Hand of Domenikos' (in Greek). Cretan, before 1567. 41.6 x 33 cm Benaki Museum, Athens

Christ. Theologically the representation of the incarnation was also seen as an iconophile trump card to demonstrate the necessity for making icons: that Christ was made flesh meant that his divinity and humanity could, and indeed should, be represented in human form. In the fourteenth century, when the British Museum's Triumph of Orthodoxy was painted, it was additionally believed that the Hodegetria icon at the Hodegon monastery in Constantinople was the actual original painting by the hand of St Luke. This historically optimistic identification begins to circulate in Byzantine texts in the eleventh century. There were many copies of the Hodegetria icon, as there were of other icons of the Virgin. The logic was that powers inherent in the original could pass into later versions (such as fig. 10). The Byzantine world contained many versions. Copies are also found in Russia, and as far away as Ethiopia; they were equally common in the Catholic west, especially in Rome, where estimates of over six hundred such panels have been made. One consequence of the idea of St Luke as a portrait painter of the Virgin and Christ is that this itself became a popular subject in due course for both Byzantine and western artists.

The supposed original Hodegetria icon in Constantinople was the source, according to several texts, of daily miracles. In the fourteenth century it was such an important cult image that it was made accessible to the public and carried out of the church into a courtyard every Tuesday, occasionally being taken to St Sophia and displayed there. We have an eyewitness account by the Spanish ambassador from Seville, Ruy Gonzáles de Clavijo, who visited the church in 1403 and observed that 'all present make their prayers and devotions with sobbing and wailing'. Such contemporary texts offer a direct insight into the use of icons in Byzantium. In the case of the Triumph of Orthodoxy they help us to understand the reasons for the choice and relationships of the various elements in the icon and how the inclusion of the Hodegetria gave it both an emotional and an intellectual dimension. The individual figures give a range of models of the good Christian life, and collectively evoke Orthodox history and values. The icon is an example of what it means to claim that 'eternal truth' is at the centre of Byzantine religious art. At the same time it shows through its exquisite handling of the tempera painting technique that icons are as much works of 'art' as they are vehicles of theological exposition. Although the Triumph of Orthodoxy icon is filled with historical figures who became well known in Byzantium because of their perceived role in the opposition to and defeat of iconoclasm, the particular choices and emphasis only make sense within a fourteenth-century perspective. In 1370 the Synodikon of Orthodoxy was given its final Byzantine revision when the doctrines of Gregory Palamas were integrated with

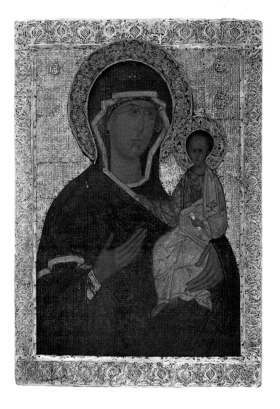

10. Icon with the Virgin Hodegetria, with silver-gilt and enamelled revetment

Russian, ?sixteenth century.
74 x 52 cm
British Museum

the veneration of icons. The significant number of church councils in Constantinople during the fourteenth century shows that Orthodoxy and its definition were of prime interest at the period in which the icon was painted. The development of the imagery of the Triumph of Orthodoxy may well have been the visual outcome of this activity, and perhaps acted as its affirmation.

Nothing is known of the history or whereabouts of the British Museum's Triumph of Orthodoxy icon between its production in the fourteenth century and its appearance in a private collection in Sweden, except that it was seen by the artist of the Velimezis copy around 1500. First described when it came up for sale at Sotheby's on 15 February 1984, it was purchased by the Museum in 1988.

THE ORIGINS OF ICONS

Looking at the Triumph of Orthodoxy has highlighted several questions about Christian uses of art. It documents the historical existence of principled resistance to art as well as the growing Orthodox 'fetishism' for the icon (if that is a fair term). We need therefore to look more closely at the origins of icons. The polemics at the time of Byzantine iconoclasm in the eighth and ninth centuries (many of which re-emerged at the time of the later European Reformation of the sixteenth century) give a robust indication of Christian thinking about values and dangers of the visual arts, although it cannot be assumed that hostility to images was a predominant trait of Christianity from the beginning. In the period of iconoclasm, the issue was articulated thus: 'If God cannot be circumscribed or represented in a picture, but a man can, does an icon of Christ deny his divinity, or does iconoclasm deny his humanity?' But in the first centuries of Christianity the question more broadly was whether one could or should try to picture the unseen divinity or other world. This is an issue faced by any religion which believes in an afterlife and an eternal god, but for Christians it was aggravated by the Old Testament Second Commandment, which if read literally certainly seems to constitute a ban on icons: 'You shall not make for yourself a graven image, or any likeness of anything that is in heaven above, or that is in the earth beneath, or that is in the water under the earth; you shall not bow down to them or serve them' (Exodus 20:4 and Deuteronomy 5:8–9). While the eventual decision made in the Byzantine church was that figural sacred images were allowable both in public and in private, the debate was protracted over several centuries. The statements and practices that we can document in Byzantium show that there was a broad spectrum of opinion and that some of the faithful were as hostile to the images as others thought them vital.

The defeat of iconoclasm led to an increase in icon production. An icon made in the twelfth century, now at the Sinai monastery, shows just how effectively art can handle the unseen. This icon, the Heavenly Ladder of St John Climakos (fig. 11), is in a sense an advertisement for a best-selling book of the Middle Ages written by a former abbot of

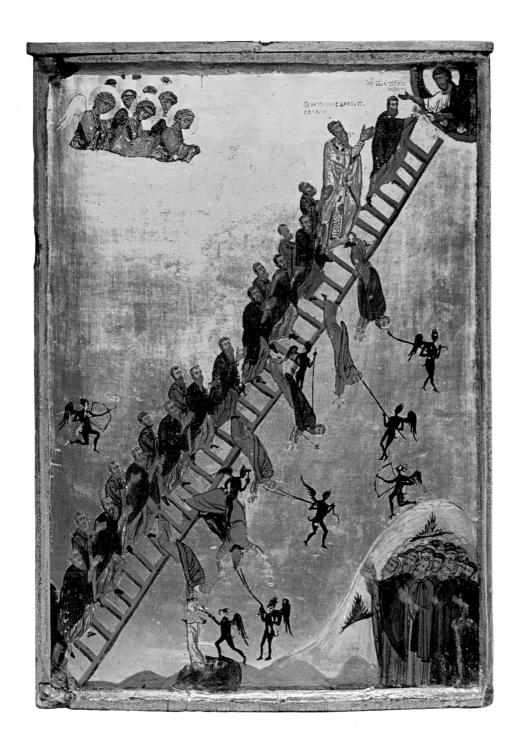

11. Icon with the Heavenly Ladder of St John Climakos

Constantinople or Sinai,
late twelfth century.
41.1 x 29.5 cm
Collection of the Holy
Monastery of St Catherine,
Sinai, Egypt

St John Climakos is at the top
of the ladder about to enter
heaven; he is followed by the
patron of the icon, who is
named the Holy Archbishop
Antonios and was probably
also the abbot of Sinai.

the Sinai monastery in the seventh century. The book was a guide aimed at monks on how to live the good ascetic life and avoid sin, and from the eleventh century manuscripts of this text included illustrations. The problem faced by the icon painter was how to turn such a discursive moralizing text into a single striking image. Pictorially the icon is all about the unseen, as it evokes the judgement faced by the soul after death: will each monk ascend to paradise at the top of the ladder or fall into the mouth of hell at the bottom? The metaphor of the ladder refers to the thirty sections of the book on how to be successful. The seventh-century author of the book and the twelfth-century commissioner of the icon, Antonios, the abbot of the monastery, are at the top of the ladder, welcomed into heaven by Christ and respectfully attended by angels. Some of the monks below will also make it to the top of the ladder; others will be seduced by devils and fall into the mouth of hell – one is already half-consumed. The book has thirty chapters, reflected in the icon by the thirty rungs or steps of the ladder. Each rung represents one year in the hidden life of Christ before his baptism at the age of thirty; the ladder is, in one sense, the unseen Christ. A Christian believer is likely to interpret the truth and reality of this imagery differently from a non-believer, and even the faithful will not agree on whether to take the image of the other world literally or symbolically.

Another issue prompted by this icon is that the modern viewer, whether Christian believer or not, comes with 'baggage', because there can be no such a thing as the 'innocent eye'. Whereas the Orthodox viewer of an icon in the church or the home will in the first place treat it primarily as an aid to prayer and not (at least overtly) as a work of art with aesthetic or critical merits which need to be recognized, other viewers will have differing responses. The art historian, for example, will expect to assess the work's quality and style and ask questions about its date, patron and artist. The crux of this matter is whether icons are indeed 'art' at all, considering their intended function within a religious faith, and the frame of mind of the Christian viewer, who may be in a heightened emotional state when in front of the icon (as documented by Clavijo). Is the icon therefore to be treated as material production coming from before the 'age of art'? It is certainly not 'art' in the same sense that modern art may be seen as the expression of the ideas and feelings of the individual artist. This is a question to which we will return at the end of this book.

The icon of the Heavenly Ladder is a striking example of how effectively the Byzantine icon could portray the unseen deity and the other world, and as a result win over the hearts and minds of the faithful. The visual representation of Christian stories in icons can preach to the viewer that the events shown are 'true' history which really happened. Icons make the doctrines of the Christian church seem to be firmly based on historical fact, on actual events and words in which Christian truth is embedded. This twelfth-century example was the successful outcome of centuries of development in early Christian art.

Early Christian art started in the Mediterranean Graeco-Roman empire, a world filled with imagery of the pagan gods. Such images, many in the form of statuary, posed

 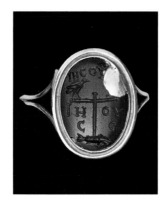

12. Three early Christian intaglios for use as a signet on a finger ring

Left: Crucifixion. Eastern Mediterranean, second or third century. 3 x 2.6 x 0.6 cm; Centre: Crucifixion. Fourth–fifth century. 2.2 x 1.7 x 0.5 cm; Right: Bird/cross. Roman, fourth century. 1.1 x 1.4 cm British Museum

the question of whether these naturalistic-looking figures were true likenesses of the Olympian gods. This was debated in ancient texts and neatly expressed in poetic epigrams, one of which, inspired by the fifth-century BC statue of Zeus at Olympia made by Pheidias, expresses the debate thus: 'Either the god came from heaven to show you his icon, Pheidias, or you went up there and saw God.' Another refers to the fourth-century BC statue of Aphrodite by Praxiteles at Knidos, and relates the goddess asking: 'Paris, Anchises and Adonis saw me naked. Those three are all I know of. So how did Praxiteles see me naked?' Byzantine intellectuals knew these epigrams and reworked them, as in this one describing an icon by a twelfth-century artist called Eulalios: 'Either Christ came down from heaven and showed the exact form of his features to him who had such expressive hands or else the famous Eulalios ascended into the sky itself and with his skilled hand accurately portrayed the appearance of Christ.' Texts like these show how Byzantine viewers of icons inherited traditions of thinking about art which went directly back to Classical antiquity. But in fact very few Byzantine texts can give us any kind of guide on how such viewers assessed the artistic quality of any single icon. It is one thing for them to speak of 'lifelike' representations of the Virgin and saints in icons, but what exactly they meant by this leads us to apply such ideas as the 'period eye' in order to explain our suspicions that we and they are seeing icons differently.

In the context of the history of art this question is usually phrased in terms of how relative and complicated a concept is contained in the Greek word *mimesis*, which is also used in the description of antique art. But the value of the Byzantine texts, however rare and opaque, is to warn us against regarding the medium of the icon as inherently anti-Classical. Nor should we think that all early Christians were deeply offended by the multiplicity of imagery that surrounded them: statues of pagan gods and emperors, death masks of their families, portrait panels and even pagan religious panels that in their forms and techniques actually overlap with those of the earliest icons (see chapter four). Some early Christians, like some ancient viewers, did imagine that statues contained evil spirits

and were dangerous. The imperial cult and its art was a challenge too, since Christians refused to worship the emperor as a god, and therefore would not sacrifice to him; this led to a number of persecutions of Christians by the Roman authorities who enforced this token practice. But Christians had one great certainty: as far as they were concerned they knew that the pagan gods were a fiction and that all images of them were false. Christian art must by definition be completely different, since it represents truth.

The Christian debate on seeing the unseen is already embedded in the New Testament, both in the Gospel of St John ('The word was God . . . and the word became flesh and dwelt among us') and in the Letter to the Colossians (I:15), 'Christ who is the image [icon] of the unseen God'. This means that, from the beginning, two key ideas are stated in the Christian texts that everyone knew and spent much time interpreting: one was that the incarnation of Christ offered an image of the unseen Father; the other was that the image of God was the Word and the Word became flesh. Thinking about the functions and nature of Christian images must have begun very early on, and there are scattered remarks about icons of Christ in texts from the second century onwards. But only during the period of eighth-century iconoclasm is the case in favour of icons set out in a fully rationalized form. This is in the writings of the iconophile theologian St John of Damascus, who was a monk outside the frontiers of Byzantium, in the monastery of St Sabas overlooking the Dead Sea. In other words, iconoclasm provoked theologians to set down their justifications for the production of icons and to explain why holy images were necessary in the church. In his *First Apology For Images*, John argues that the making of images is forbidden in the Old Testament text of Exodus because of the idolatry special to that time and because it is impossible to make an image of the immeasurable, uncircumscribed, invisible God. But this situation, he reckoned, only applies to Jews. Christians accept the New Testament, and thereby the rules are changed. Christians differ from Jews; they are able to treat images properly and to adore God through them. Although no one can ever see the form of God, Christians have been enabled to draw a likeness of him, enveloped in human form. Christ is the image of the invisible God, but he is not identical to the archetype.

John of Damascus deals with this issue slightly differently in the *Second Apology For Images*. We do not make images of the one who is without body or form – he says that would be wrong – but in Christ we see God 'through a glass darkly', and so an icon is a dark glass, fashioned according to the limitations of human nature. John realizes that he cannot base a case for the legitimacy of icons of Christ and the saints on the text of the Bible alone, and so he has to attack as fundamentalist the iconoclast emperors because they think church doctrine can be defined solely through the Bible and then imposed by imperial decrees. What has to be taken into account, according to John of Damascus, are a number of unwritten traditions accepted by the church, such as the decision 'to make icons of Christ, the incarnate God, and of the saints; to bow down before the cross; and to pray facing the east'. These traditions, he argues, are as binding on Christians as the Bible.

So it emerges that the fundamental problem was not whether to represent divinity but how to do so. Even if Christ was the image of the unseen God, no one could know what Christ looked like, as there were no contemporary portraits made, and extraordinarily little in the way of description is to be found in the Gospels. While it is reasonable, therefore, to expect some sort of early Christian art, there is considerable difficulty in finding it. One factor is that this was an illegal, and so secretive, religion which expected the Second Coming to happen 'tomorrow': there can hardly have been a compelling motivation to build cult monuments with decorations. In any case meetings and services were held discreetly in private houses. But it may be too negative to conclude, as art

13. First page of the Gospel of St John from the Codex Sinaiticus

Eastern Mediterranean, c. 350.
British Library, London

This is one of the earliest surviving copies of the whole Bible in Greek, the Septuagint, and is possibly one of the Bibles commissioned by Constantine the Great. It was in the collection of the monastery of St Catherine at Sinai until the middle of the nineteenth century, when the Russian scholar Constantine Tischendorf took most of the pages to Russia. The British Library purchased its 694 pages in 1933.

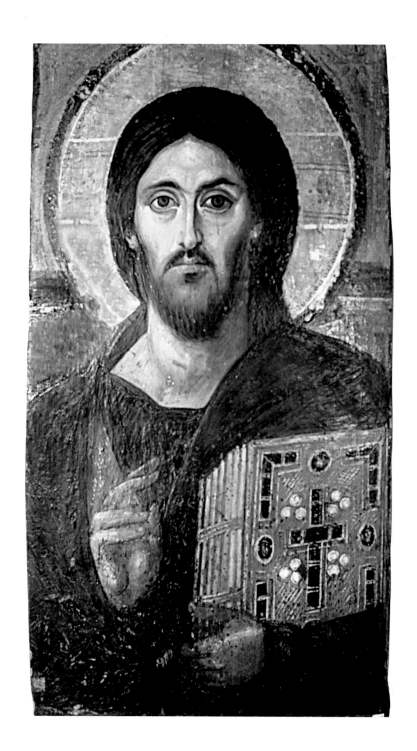

14. Icon with Christ

Byzantine (Constantinople),
sixth century.
84.5 x 44.3 cm
Collection of the Holy
Monastery of St Catherine,
Sinai, Egypt

historians generally have, that there was no Christian art before the third century, except perhaps concealed in the ambiguous imagery on tiny seal stones and gems (fig. 12). One might argue instead that the earliest form of Christian art was writing, showing Christ as the Word (*logos*), and that the manuscripts of the Gospels are both holy scripture and art. It is difficult not to regard the calligraphy of the Codex Sinaiticus as equally art and holy text (fig. 13). One of the priorities during the first centuries of the religion was to solve the highly contentious issue of which of the many writings about Christ were authentic. How could a canon be agreed and presented? The solution did not really emerge until Constantine the Great sponsored a set of Bibles in the fourth century, and by this affirmative action fixed the canon of the New Testament, with four Gospels.

Christian art became recognizable as such in the first half of the third century. Figurative images and cycles from this date can be found both in the west at Rome in sarcophagi and the catacombs, and in the east at Dura Europos in Syria, where a baptistery with wall paintings was excavated in the 1930s. The paradox in this city is that figurative Christian art appears at the same time as figurative Jewish art: the excavations at Dura Europos uncovered painted temples, a Christian house church and a synagogue, all in use by around 240 but abandoned when the city was destroyed in 256. This sets a problem of interpretation: what can best explain the emergence of Christian and Jewish figurative art at the same time and in the same styles as traditional pagan art? The most frequent art-historical explanation is that art was operating in the service of polemic, and that figurative art was developed as the most direct and eloquent battleground in which to promote the beliefs of competing religions. It functioned as a missionary tool within the familiar (and therefore effective) conventions of antique art. Nevertheless, whatever stimulated the emergence of this Christian art, once the icon became part of the Christian experience its purposes became progressively more and more varied.

Despite the rapid expansion of Christian art in the fourth century after Constantine the Great legalized the religion, the problem of how to depict the unseen God remained troublesome. Various strategies were tried, such as representing Christ symbolically in the form of a fish (the Greek word for fish, ICTHUS, was an acrostic for Jesus Christ Son of God) or as the Good Shepherd (repeating the *Moscophorus* imagery of the Classical world). But whichever form was used for the figure of Christ, his exact appearance while on earth remained an enigma. It was only in the sixth century that a breakthrough can be detected. The solution was the development of a very special type of icon, the icon 'not-made-by human-hands', in Greek *acheiropoietos*. These representations of the face of Christ appeared in several places in the Byzantine world, most famously the mandylion (a napkin with an imprint of the face of Christ, like the later western Veronica cloth) at Edessa and an image found in a fountain by a pagan woman, Hypatia, at Kamoulianai in Asia Minor. At the same period we find texts purporting to describe the appearance of Christ and his bodily measurements. A possible copy of one of these sixth-century

acheiropoietos icons is the icon of Christ at Sinai (fig. 14). Its relatively large size (now 84.5 x 44.3 cm, originally larger) suggests that it was made for devotion and prayer in that church. As an *acheiropoietos* icon it would have been regarded as the genuine face of Christ while he was on earth and as a miracle-working image. What is so remarkable a feature of these icons is their special nature, somewhere between art and relic. This ambiguity gave them heightened powers, and we hear that they were carried in processions and even into battle.

Once the portrait type of Christ showing him with a beard and long hair was established in sixth-century Byzantium, it became the accepted form of his image throughout the Middle Ages in both east and west, though probably the need was always felt to give better and better justifications and proof of its authenticity. This at least explains the appearance of the Veronica cloth in a later period and especially of the remarkable shroud with a full-size 'miraculous' imprint of the body of Christ. This is now in a special setting in Turin Cathedral, but it first emerged in a church at Lirey in France in the middle of the fourteenth century where it was displayed as the actual cloth in which Christ was wrapped and buried after the crucifixion. At this period Europe was awash with relics and miraculous icons and the appearance of the Turin Shroud led to an acrimonious correspondence between the Bishop of Poitiers, the Pope at Avignon, the King of France and the canons at Lirey over its authenticity. The bishop argued that the shroud was a painting and that the fraud had been exposed already by Bishop Henri of Poitiers, who had conducted an investigation which 'after painstaking study and exploration of the matter, found the deception, and how the cloth had been artificially painted, a fact confirmed by the very man who had painted it: that it was the work of a human being and had not been miraculously made or bestowed'. Consequently the church at Lirey was ordered to stop making viewing charges and to admit that it was merely a copy of Christ's shroud. The debate about whether this is the original shroud of Christ continues today. The scientific testing of the textile, resulting in a carbon-14 dating in 1988 which confirmed its fourteenth-century date, is still under challenge; one might want to ponder whether medieval religious scepticism was more rational than modern scientific credulity.

The appearance on the historical scene of the 'miraculously produced' Turin Shroud in the later Middle Ages can be regarded as a further indication of the recurrent Christian need to justify the authenticity of the true portrait of Jesus. But it does not explain why it was this particular image of a bearded, long-haired Christ that became the 'true' portrait in the sixth century and afterwards. Was the acceptance of this imagery a consensus conceived and imposed from above by intellectuals or did it emerge from popular religious attitudes? We can perhaps trace some of the steps in the process. The earliest images of Christ showed him sometimes as youthful – often this correlates with the Christ who is able to perform miracles or, as in the Triumph of Orthodoxy, as Emmanuel – and sometimes as a bearded mature figure, in the tradition of the ancient teacher and

philosopher. Either way the images necessarily must act to communicate the divinity and charismatic power of Christ. This might have worked through association, so the young figure of Christ may evoke the tradition of the ancient gods and heroes, such as Apollo, Dionysus and Alexander. If so, this may tempt us to wonder if the bearded Christ might have echoed the image of Zeus/Jupiter. Indeed attempts have been made to connect the invention of the 'true' portrait of Christ with a direct artistic imitation of the face of Zeus. The text used for this hypothesis survives in some fragments of the *Ecclesiastical History* of Theodore the Reader (before 527), which relates that Gennadios (Patriarch of Constantinople 458–71) interceded when an artist, at the request of a pagan (the term used is 'Hellene'), made an icon portraying Christ in the likeness of Zeus. The artist immediately suffered divine retribution: his hand withered, since he had committed blasphemy. Luckily for him Gennadios was able miraculously to heal the hand through his prayers. This miracle is also recounted by John of Damascus, who adds a description: 'the hair on the head was painted as dividing on either side so that the eyes were not hidden. For in such manner, the Greeks painted their Zeus.'

15. Silver coin with the head of Zeus

British Museum.
This coin was struck for the Games at Olympia (in Elis) in 360 BC.

It has been pointed out that one of the most famous statues of antiquity, the Chryselephantine cult statue of Zeus from Olympia, made by Pheidias in the fifth century BC, was in Constantinople in the fifth century AD. It had been collected, together with other equally famous cult statues such as Praxiteles' Aphrodite of Knidos, by a Byzantine imperial official called Lausos who set up a large ancient sculpture display in his palace in the early fifth century. Both these statues are mentioned in the epigrams already quoted, and became as much part of Byzantine culture as the Parthenon Marbles have of British culture. It may be questioned whether Lausos actually acquired the complete original fifth-century BC piece, but since the Emperor Theodosius I abolished the Olympian Games in 393, a good case for its subsequent redundancy can be made; the historian Cedrenus, when describing the collection, states very clearly, 'the ivory Zeus by Pheidias, whom Pericles dedicated at the Temple of the Olympians'. Sadly the collection was mostly destroyed by a fire in 475.

Since this statue collection demonstrates that the Byzantines had first-hand knowledge of the portraiture of Zeus from this model (and no doubt from other sources), the suggestion has been made that the sixth-century *acheiropoietos* icons of Christ and their copies had formed their imagery of Christ in imitation of Zeus/Jupiter. The Byzantine texts used as the basis for this suggestion at the same time hint that this would have been a controversial model. John of Damascus adds a sentence revealing that 'the historian [Theodore the Reader] says that the other type of the Saviour, the curly and short haired, is the more truthful'. Iconophile writers in the ninth century add more with another story relating that in paintings and mosaics in the Holy Land Constantine the Great represented Christ 'as the ancients had described, with eyebrows that joined, fine eyes, a long nose, frizzy hair, a black beard, flesh tones like his Mother's, the colour of wheat'.

16. Gold 'nomisma' (coin) of the Emperor Justinian II

Minted in Constantinople, 692–685.
British Museum

This emperor was the first to put his own portrait on the reverse of coins and to put a bust of Christ on the obverse. This version of the portrait of Christ with long flowing hair and a beard most likely reproduces a famous miraculous icon of the period.

In fact by the ninth century descriptions of Christ had become much more detailed, such as that by the monk Epiphanios (c. 800):

> he was extremely handsome, six feet tall with blondish hair, not too thick, and lightly waved; the eyebrows black and not very arched, the eyes clear and brilliant; he had beautiful eyes, a long nose, and long, blondish beard, since a razor had never touched his face, nor even any human hand except for his mother's when he was an infant. The neck slightly bent, just enough to avoid being rigidly upright, his colour that of wheat; his face was not round, but, like that of his mother, drawn toward the chin, the cheeks lightly coloured, just sufficiently to reveal his pious nature, sage, calm, and maintaining always a serene humour without anger.

Yet this portrait of a bearded Christ which has dominated Christian art since the Byzantine period cannot convincingly be derived only from images of Zeus, despite the obviously appropriate evocation of the 'King of the gods'. For one thing, and at a very basic level, the exact rendering of Christ's long hair seems to deviate from the normal iconography of the head of Zeus (fig. 15). This issue is also brought up in a text attributed to Epiphanios of Salamis (d. 403) which complains about paintings of Christ with long hair (on the illogical grounds, which he criticized, that Christ was called a Nazarene and so ought to have long hair). Maybe the moral is that, while the ancient gods and Christian saints could be pictured in many forms, there were fewer ways to express the idea of a charismatic male leader. In other words parallels between the imagery of Christ and that of the ancient gods are not to be dismissed, but using terms like syncretism or continuation of antiquity to describe the meeting of antiquity and early Christianity can, unless defined very carefully, be misleading. Many aspects of the cultures of antiquity have persisted in all manner of ways, both into the early Christian world and to the present day. But they take on different meanings at different times, often, no doubt, distorted ones. A common word to describe the process in the early Christian period is transformation. This fits well the idea that behind the representation of Christ lies the imagery of polytheism, and that the new religion and its icons overlap with the past but transform it into a new type of art and society. In this sense the icon looks back to ancient and Jewish religious ideas, but as a Christian art it takes on new functions and appearances.

As for the sixth-century *acheiropoietos* icons of Christ, while they must have solved some questions about how to represent the unseen God in whose image Christ was

made flesh, they also instigated new problems. How far did they represent only the human part of his nature? These images were soon to be a breeding ground for new heresies, reflected in a contentious but common modern interpretation of the Sinai Christ:

> The icon represents his two natures, to the right, the arched eyebrow, sunken cheek, moustache and mouth drawn down in a sort of sneer suggests the stern, condemnatory divine nature of God in judgement; to the left, the more open friendly and sympathetic gaze suggests the more benign human nature.

This reading of the icon is not found in Byzantine texts, and is therefore speculation. Nevertheless the imagery of these miraculous icons must have provoked strong reactions, and some of the practices connected with early icons (we read of the sick scraping the paint off images of saints and mixing it with water to swallow as holy medicine) are likely causes of a revulsion with icons which led some viewers to espouse iconoclasm around 730.

The possible causes of iconoclasm have often been explored. It would be in line with the explanation for the emergence of Christian figurative art in the third century to see it similarly as a tool in the polemics between competing religions. Iconoclasm breaks out at a period when the rise of Islam might have led to an attempt to redefine the 'brand' of Orthodox Christianity in the face of a new enemy. This may be part of the explanation for its outbreak at this particular time, but is hardly satisfactory as a full historical explanation. It is clear that a long-standing debate about the power of icons was already in progress in both the church and the imperial palace. Such discussions are reflected in the church councils over which the emperor presided, such as the Council in Trullo of 691/2 chaired by Justinian II, the first emperor to put a representation of a bearded Christ on his gold coins (fig. 16), probably derived from a miraculous icon. The expansion of images after this church council, held in Constantinople (also known as the Quinisext Oecumenical Council), may have set up a fierce dialectic between differently minded groups in Byzantium, leading to iconoclasm and its imposition of an alternative sort of visual spirituality, centred on representations of the cross rather than the face of Christ.

Iconoclasm ended with the re-emergence of figurative art, giving Orthodoxy its enduring identifying feature: the icon. The Triumph of Orthodoxy leads us full circle back to Byzantium's own history of art and the belief that the icon began with St Luke. Not only one of the evangelists, he was also an artist who painted Christ and Mary from life. Not surprisingly the icon said to be painted by St Luke, the Virgin Hodegetria, was hacked to pieces by the conquering Islamic Turks in 1453.

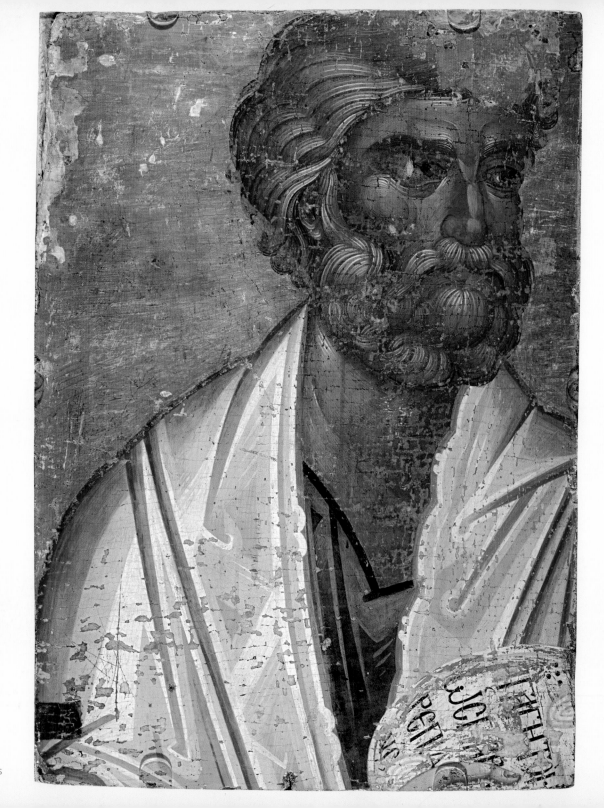

How to make an icon

Since icons have been a feature of Christian life from very early on, and continuously produced to the present day, it is not surprising that the medium is a highly refined one. But it is also very traditional, with painters having worked in the same way for centuries. Although in some respects the modern technical examination of icons is not as well documented as that in other fields of art history, the main lines of the history of icon technique can be clearly described. The icons in the British Museum help us to build up a dossier of factual information. This can best be seen if we look at the fourteenth-century icon of St Peter (fig. 17) in the light of the technical evidence which has been found in the course of the examination of its history and condition.

The most frequently quoted source of information about the practice of icon painting is the so-called *Hermeneia* or *Painter's Manual* compiled by Dionysios of Fourna in the early eighteenth century. This is one of several collations of material made by icon painters mostly in the eighteenth and nineteenth centuries, but perhaps containing recipes and methods that go back to lost writings of the Byzantine period. Dionysios is the best known because his instructions, which cover both how to make an icon and how to represent all the key icon subjects, were published by a French scholar, Adolphe-Napoléon Didron (1806–67), after he had found painters at work on Mount Athos in 1839 using a copy of the text. Didron's publication of 1845 was based on a copy made for him and sent from Athos. The best edition of a Greek text of the *Hermeneia* was published in St Petersburg by A. Papadopoulos-Kerameus in 1909, and this was translated into English by Paul Hetherington in 1974 as *The 'Painter's Manual' of Dionysius of Fourna*. Considerable

17. Icon with St Peter

Byzantine (Constantinople),
early fourteenth century.
68.7 x 50.6 cm
British Museum

recent research has been devoted to contextualizing both the text and life of Dionysios (c. 1670–c. 1745/6), a priest, monk and artist who worked in North Greece and on Mount Athos; some of his paintings survive there.

The icon painter needed a number of highly specialist skills as the making of each icon went through several different stages. The first was choosing and preparing the hardwood on which the icon was to be painted. The selection was made from a number of trees, the most common being lime, poplar, elder, birch and cypress. Resinous trees, such as cedar and pine, were also used and the aroma of these woods may well have been a factor in their choice as an object to be used in the incense-filled atmosphere of the Orthodox church. The best cuts came from the centre of the trunk where the growth rings were symmetrical and so there was an easier grain to work with. Once chosen, the wood was stored for seasoning. When it came to deciding the size of the icon, if a large panel was needed, two, three or even four sections might be joined together. The resulting panel was often hollowed out from the centre in order to make a raised frame around the central picture. This is the case in the Triumph of Orthodoxy and other icons in the British Museum's collection. Unusually the frame around the thirteenth-century St George icon was made by building up an artificial frame of gesso, parchment and even some paper (see fig. 41).

The ways in which the sections of wood are joined can always best be discovered by turning an icon round and looking at its back (fig. 18). It has been said that Russian conservators of icons were trained always to start their examination from the back, looking first at the wood and construction of the board. The back reveals how individual workers managed the joining of any sections and how they tried to prevent damage to the painting, anticipating that the wood would bow in the course of time. Sometimes the back might be braced with thin battens of the same wood or wooden slats were let into it. Various types of dovetail and butterfly joints, as well as struts and pegs, were employed to strengthen larger icons. Nails were sometimes hammered in to stabilize the wood. The ever-present dread of bowing was sometimes a motive for painters to decorate the back, although another reason to do this is to give a good finish to a panel that may be visible to the public from both sides. Sometimes the backs of icons are smooth, sometimes they are roughly chiselled, and sometimes they are carefully prepared and painted. The back of the icon of St George is decorated with a cross (see fig. 46).

Once the wood was seasoned and the carpentry carried out, the next stage was to size the panel with glue. This description of icon production, it should be admitted, assigns each stage of preparation and painting to the artist. It is of course possible that some of this work was done by different specialists working together in a 'workshop', which might include a carpenter and a joiner. We do not have any descriptions of workshop organization in the Byzantine world, and the discussions of artists and workshops in the literature derive from direct examination of icons and deductions made from what can be seen. They must therefore be taken as tentative reconstructions of how things

were done. Most discussions assume that the icon painters were men, and that this was not a profession (unlike those for embroidery and tapestry) which was easily accessible to women.

The standard way of making glue was to boil up animal skin and bones. The *Hermeneia* gives full instructions on how to manage the skins, recommending that glue be prepared in cold weather in order to avoid the pungent smell that is given off in the heat. After sizing the panel with glue, often, but not invariably, a loose-woven linen was glued to the front side and allowed to dry. The idea was that this would serve as a binder for the layer of gesso or at least might help to prevent the painting from instantly cracking apart if the wood split at any time. The panel was now ready for the application of several coats of thin gesso (chalk or gypsum mixed with glue and water). Each layer was allowed to dry and was smoothed. As many as eight layers of gesso might be applied, each one ideally being very thin. According to the *Hermeneia*, anyone working too fast and with the layers too thick would find to their cost that the coats will separate and the image will be uneven. The final layer was carefully smoothed (a cuttle bone was the best instrument) and polished with a cloth dampened in oil. Best practice was then to leave the panel to stand for a few months or even over a year, but this must have been difficult to achieve when a panel of special dimensions was commissioned within a tight timetable.

The first stage of painting an icon began with a freehand drawing in charcoal on the gesso. Sometimes the gesso was incised so that the original outline could still be detected as the colours were built up. A compass was used for drawing the haloes, and it has been argued that a compass and dividers were essential tools for a Byzantine painter as they helped to determine the proportions of figures in the compositions, perhaps (and this is controversial) using the nose as a module. As work on the panel began, the painter needed to plan for the use of gilding. Rarely, and only in the most expensive and prestigious icons, was the whole of the panel surface gilded. More usually only the areas where haloes were planned were covered in gold. The preparation for gilding was to apply a bole, consisting of red or yellow clay, mixed with glue. This was applied like paint. Thin sheets of gold leaf were laid onto the bole as it set. After settling, preferably for at least twelve hours, it was burnished using a dog (or wolf) canine tooth mounted on a small stick; an agate burnisher was an alternative. A gold halo could be embossed or decorated with tooling. One question that arises when looking at an icon with an all-over gold background is whether this is indeed all gold leaf: frequently it was not. Icon painters knew how to simulate gold and thus avoid the expense of such a quantity of gold leaf. Silver or more likely tin foil was used in place of gold leaf and painted over with a varnish (a

18. Back of icon with St Nicholas

Russian, late eighteenth century. 22.7 x 17.8 cm British Museum

19. Icon with the Mother of God of the Sign, with silver revetment (oklad)

Russian, c. 1838.
31.5 x 26.8 cm
British Museum

yellowish gold lacquer made of hot linseed oil, vegetable gum and yellow pigment). This trick had already been written down in the eighth-century Lucca manuscript from a monastery in North Italy, and became increasingly common in late Russian icons, as will be seen in chapter five.

The icon painter normally used an egg medium (tempera), and only in pre-iconoclasm icons, or in very rare later post-iconoclasm examples, do we find the ancient technique of a wax medium (encaustic), well known in Roman mummy portraits from the Fayum in Egypt. Until more technical analyses of icons have been published, we have insufficient information about the handling of the media to be confident or precise about workshop practices. Examination of the icon of St George revealed that some oil was used as well as tempera, and such a mixture of media has been found in medieval art in the west too. Icons were regularly varnished after the painting was completed. It is reasonable to assume that an icon was painted in tempera, unless evidence to the contrary is produced. The medium was made from egg yolk mixed with a drop of vinegar and then used with pigment ground in rainwater; it was excellent for the production of bright colours and for durability.

The number of pigments used in icons is quite limited, mostly consisting of earth colours. In addition we find azurite, cinnabar, malachite, verdigris, and white lead and bone black. Byzantine painters, whether working on mosaics, wall paintings, manuscripts or icons (and it can be deduced from a few texts and attributions that there were some individuals versatile enough to work in all these formats) worked through the composition, progressing from cooler dark or medium tones to warmer lighter ones. The landscape areas around the main image were done first, then the garments and finally the flesh of the hands and face.

The technical processes for the making of icons are remarkably consistent over a long period of time. As the centuries passed, new varnishes, pigments and other materials became available and some must have been tried and adopted, but the eighteenth-century *Hermeneia*, with its insistence on the superiority of traditional practices, shows how conservative was the world of icons. What is noticeable in the long history of icons is not an interest in new methods and materials, but rather a persistence of high virtuosity and refined workmanship: icons do endure well, both physically and visually. But this traditionalism did not prevent the development of new modes such as the 'paper

icon', produced when printing facilitated the speedy manufacture and circulation of cheaper, mass-produced icons. Innovation is also apparent in the introduction of new styles and subjects into Orthodox icon painting in response to knowledge gained through the circulation of books, prints and objects of western styles and subject matter. In the case of El Greco in the sixteenth century, we have an exceptional (but not entirely unique) case of an icon painter trained in Crete who could adopt western forms (see fig. 9). Domenikos Theotokopoulos, as he was named at his birth in Candia (now Iraklion), left the island in 1567 at the age of twenty-six, retrained in the use of oils in Venice, and later established himself as a major painter in the Catholic world of post-Reformation Spain.

Although the techniques of icon making are so consistent over the centuries, the history of the icon has always been periodized. The fall of Constantinople in 1453 had brought to an end the idea of an imperial Byzantine world centred on Christian Constantinople and the political and social collapse of the old Orthodox world was deeply traumatic in the Mediterranean lands. Whereas the art of the icon continued to develop in the cities and monasteries of the Russian lands, the Byzantine world was disrupted. The term most frequently used to describe the period after 1453 is Post-Byzantine ('after Byzantium'), but this is hardly an evocative label, except perhaps inadvertently to portray icons produced after that date as little more than nostalgic and static products. A way to avoid these period terms dominating the field of icons is to recall the ways in which icons were described in the Orthodox world itself. Recent publications and studies of monastic foundation charters (*Typika*), which sometimes include inventories of icons and other possessions, have made this information easily accessible. Although in Byzantium icons were not identified by 'titles' in the way that we refer to works of art in our time, they may be identified by their subjects in the inventory descriptions. Here, as an example of Byzantine icon description, are three items taken from the inventory of the eleventh-century *Diataxis* (Rule) of Michael Attaleiates for a monastery of Christ which he endowed. The first item is a triptych with a central panel of Christ in silver and two wings showing a different set of saints depending on whether the triptych was open or closed; the second is an icon of St Catherine and saints; and the third is an icon of St Panteleimon, richly embellished with precious stones:

> A silver icon, and gilded support, with a bust of the Saviour, with two wings; on the interior the wings have the most holy Mother of God and the venerable St John the Baptist, the holy apostles Sts Peter and Paul, St Artemios and St Loukilianos; on the exterior they have the holy martyrs George, Akindynos, St Nicholas and St Methodios, St Kosmas and St Damian.

> Another painted wooden icon of St Catherine with silver gilt frame, having six bust images and two standing images.

Another painted wood icon of St Panteleimon with a silver-gilt frame and twenty five jewels, with sixteen icons around the frame.

Another typical item comes from the inventory of the twelfth-century convent of the Mother of God Kecharitomene in Constantinople. It reads:

Another new icon, painted on wood, Christ Enthroned, and below similarly the Mother of God and on this side and that of both of them Peter and Paul and the Saints Theodore with a silver gilt frame and a similar ring.

Even more lavish is the record of an icon which the nephew of the founder (Theodora Synadene) gave to the fourteenth-century convent of Bebaia Elpis in Constantinople:

A gold icon of the all-holy Mother of God, all with pearls, and with eight precious stones, four red, the other four light blue, together with veil all over with pearls, a so-called *syrmatinon*, bearing an image of my all-holy Mother of God.

The information found in these and other inventories gives us an insight into Byzantine ways of thinking about a collection of icons. It is revealing to find that attention is focused usually on the subject matter, size (whether large or small), form (whether single panel or diptych, etc.) and materials or technique. Furthermore the way in which these lists are ordered and the nature of the detail recorded in the descriptions points to one key factor of the Byzantine perception: that icons were appreciated not for their stylistic features or date, but rather for their adornment. Byzantine viewing was very different from that of the modern art historian. What was prized was the richness and cost of the embellishment with precious stones, gold and silver frames and revetments. Such highly embellished icons are listed first, while 'ordinary' painted panels come later on in the lists. In other words, it was the expense of the components of the icon which ranked its importance. The addition of precious materials to icons and paintings may have begun before iconoclasm, but certainly became increasingly popular after its end. Already in the eleventh century the practice is documented in Constantinople and elsewhere; for example the large icon of Peter and Paul from St Sophia at Novgorod in North Russia was almost completely covered by precious metal. From the ninth century onwards there are examples of fully painted icons to which are added such revetments. Many examples are known in Russian icons, where decorated metal plates (known as *oklad*) are nailed into the wood and where covering over the whole icon becomes common (fig. 19). In Constantinople the fashion was increasingly popular after 1261, and one way for the rich, and the not-so-rich, to make a church donation was to add a precious-metal revetment

20. St Sophia at Istanbul from the west in 1847

Colour lithograph from Gaspare Fossati, *Aya Sofya Constantinople*, London, 1852, pl. 25.

The mosque of Aya Sofya was restored by the architect brothers Gaspare and Giuseppe Fossati between 1847 and 1849. They consolidated the much-dilapidated building (dating from 532–7), and even uncovered and recorded many of the Byzantine mosaics, although they were instantly reconcealed under plaster until the modern restoration began in 1931 after St Sophia became a museum. The great domed masonry structure nestles among wooden houses, recalling the medieval aspect of the city, prone to fires and earthquakes.

to an icon, preferably a famous one. The icon of the Virgin Hodegetria in Constantinople, already discussed in chapter one, is a striking example of the practice. According to the Spanish Ambassador Clavijo, who was in the city in 1403, that large icon 'is now covered over by a silver plate in which are encrusted numerous emeralds, sapphires, turquoises and great pearls with other precious stones'.

At this point the question must arise of whether we can discover what was the cost of an icon in Byzantium. One particularly informative document mentioning icons is known from the archives. This is an inventory of the possessions of a wealthy family (that of Manuel Deblitzenos) in Thessaloniki in 1384, amounting in all to a value of around a thousand *hyperpyra* (the name given to the standard gold coin or *nomisma*). The annual revenue of the head of the family was 70–80 hyperpyra. The figures give a cross-section of the values of his possessions, including those of seven icons. Values given for other items include: 'a kettle – 2 hyperpyra; a towel – 2 hyperpyra; used mattress and blankets – 4 hyperpyra; used silk blankets – 6 hyperpyra; old bedcover of fox fur – 7 hyperpyra; horse – 14 hyperpyra; good silk blanket – 32 hyperpyra.' The key information provided about the seven icons is that each of them was 'decorated', though not with precious stones, and their valuations ranged between 7 and 2 hyperpyra. One was

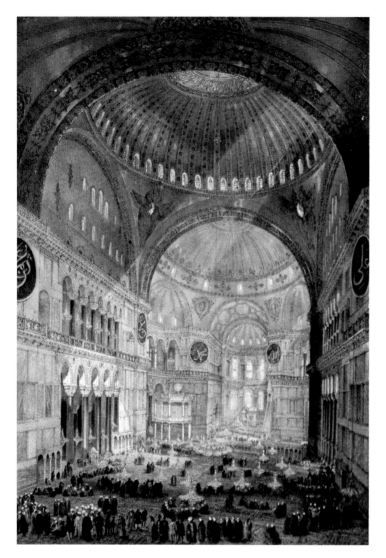

21. Interior of St Sophia in use as a mosque in 1847

Colour lithograph from Gaspare Fossati, *Aya Sofya Constantinople*, London, 1852, pl. 3.

worth 7, one 6, one 5, three 4 and one 2. These are clearly not highly expensive items, and there are no simple plain painted icons listed; perhaps the household also included such icons, but they were not considered worth listing in the inventory.

Looking at the techniques used in making icons points to the conclusion that the expertise of icon painters was passed on from generation to generation, and that change was not encouraged by the process; rather what mattered was the consolidation of traditional practices. It is generally assumed that this worked through a system of apprenticeship where it was frequently fathers training their sons. But it does not follow that workshop practice and its apparent inbuilt conservatism totally inhibited change. Nothing was more radical in its effects on the viewing of icons than the idea of attaching precious revetments which changed the character, texture and the prestige of the painted icon. Nor should one underestimate architectural changes in the Orthodox church, which in the course of time altered the congregation's lifelong experience of the regular liturgy and other services, and enhanced the status of the clergy. Along with the changing functions of the icon came new subjects and new forms. The icon is not an immutable form of art: it really does have a 'history'.

Changes to the environment in which icons functioned and were viewed continually enhanced their 'holy' status. The early Byzantine church, such as that at St Catherine's monastery, was regularly built in the form of a wooden-roofed basilica with a nave, aisles and a sanctuary with an eastern apse. This sanctuary was partitioned off from the laity by a low chancel barrier, which enclosed a special place for the clergy and the altar. From early on a number of churches were constructed as centrally planned buildings, and with the erection of St Sophia at Constantinople under the patronage of the Emperor Justinian I between 532 and 537, the domed church became the favoured design for the most prestigious churches and even for less grand ones, including the small village church. St Sophia was a stupendous architectural achievement never again

to be matched on that scale in the Byzantine world (fig. 20). What impressed the visitor was the vast height of the dome and the enormous space below (fig. 21). It was decorated with non-figurative mosaics in the vaults, though after iconoclasm a programme of figurative mosaics was installed piecemeal, with a Christ in the dome and a Virgin and Child between archangels in the eastern apse (see fig. 28). The church had shining marble revetments, a sanctuary with gold and silver furnishings and fittings, and a chancel barrier which included precious-metal revetments. It was also a repository for all sorts of Christian relics and memorabilia, and was, in a sense, as much a museum as a church. It acted as the cathedral for the Patriarch as head of the Orthodox church and as the central public church for the emperor and his family. Pre-

22. Templon screen in the nave of the church of the Panagia at Gonia Episkopi, Santorini, Greece

The church dates from the twelfth century and has a coloured marble templon, now surmounted by a wooden iconostasis. The Royal Doors are at the centre and on each side the patronal icons. The festival icons are in the wooden register above.

sumably the public had regular access to St Sophia; it was certainly the focus of special visits by ambassadors and other travellers to Constantinople. As a consequence of all this St Sophia must have entered the medieval imagination as the 'ideal' Byzantine church. By the eighth and ninth centuries the Byzantine world had gained more and more centrally domed churches, even in quite remote parts of Greece and Asia Minor. These were often relatively small and intimate constructions, and as the architecture of the Byzantine church changed, so did the organization of the sanctuary. It was now normal to have side-chapels on each side of the main apse, one for preparing the liturgical bread and wine on the north side (the *prothesis*) and the other for keeping vestments and other utensils for the priest (the *diaconicon* or vestry).

A particularly important factor in the history of the icon in the 'Middle Byzantine' church (this is the term often used for the period of Byzantine art between iconoclasm and the occupation of Constantinople by the Latins of the Fourth Crusade in 1204) was the opportunities given for new locations for icons by changes to the architectural fittings. This is most evident in the changes to the treatment of the sanctuary area which, being at the east end of the church, formed the principal axis of viewing for any visitor who normally entered through a door at the west. The liturgical rites were enhanced as a consequence of the sanctuary becoming less open, an increasingly invisible 'Holy of Holies'. This was the result of the installation of a higher screen called the *templon* screen, generally constructed from marble or wood, which more prominently divided the laity standing in the nave from the clergy at the altar in the sanctuary (fig. 22). The templon had a central doorway (later known as the Royal Doors) which gave access to the sanctuary and through which the altar could be partially seen. But equally the altar could

be concealed for dramatic effect from the eyes of the laity during or between services by fitting the templon with a wooden door and curtains.

The development of the higher templon had various visual knock-on effects. Sermons now needed to be delivered in the body of the church so that the preacher could be seen and heard, whereas in the early Byzantine church they were intended to be spoken from the apse with the preacher on the semicircular steps (*synthronon*) in the apse. This change required the addition of a pulpit in the nave or else the use for sermons of the raised platform in the nave, known as the *ambo*, whose previous function had been for readings from the Epistles and Gospels and other special ceremonials, such as the display at St Sophia of its relic of the True Cross. Another consequence of the development of the more monumental templon screen was that, as well as the doorway, the open spaces between the columns could optionally be closed with curtains or with the insertion of icons. Icons could also be added along the beam (*epistyle*) above the columns or on the piers on each side of the templon. The term 'despotic icon' is found in the art-historical literature to describe large icons in the intercolumniations on each side of the Royal Doors. In all the enactment of the holy liturgy in the church became more dramatic as a result of the developments in the templon. But equally the templon gave much greater prominence to the icon. The main icons of the church were now displayed on it, and as a result they were framed in a place that was metaphorically positioned between the earthly nave of the church and the heavenly sanctuary, declaring their status as a place of mediation between heaven and earth. The templon was therefore the natural first point of call for the visitor to the church, who would approach it and venerate the holy figures. During services, the templon also became virtually the equivalent of a stage backdrop for the ceremonial in the nave.

It is clear from the later architectural history of the Orthodox church in the Mediterranean and Russian lands that the development of the templon stimulated a yet further desire to enhance the screen between nave and sanctuary. By the fifteenth century the high wooden *iconostasis* was a feature of the interior of the Orthodox church and striking examples are found in Russia and elsewhere. Just as it is difficult to say exactly when and where icons were first added to the Middle Byzantine templon screen (probably in the richly endowed monasteries of the late eleventh and early twelfth century), so the precise stages of the expansion of the screen into the high iconostasis are also unclear. As more icons are studied and their functions clarified, an answer may emerge. It seems likely that already in the thirteenth century at Sinai there was a higher screen replacing the old templon, and such an interpretation would explain the purpose of some thirteenth-century large icons there. The screen would have consisted of a Deesis layer, with panels of Christ with the Virgin and St John the Baptist, the archangels Gabriel and Michael and Sts Peter and Paul. By the sixteenth century and later, the arrangement of the icons on the iconostasis in most Orthodox churches follows a fairly stereotyped pattern and there

23. Plan of an iconostasis

1. Crucifix
2. Patriarchs
3. Prophets
4. The twelve feasts: the major liturgical festivals
5. The Deesis (or 'Tchin'): Christ at the centre, flanked by the Mother of God and St John the Baptist and other saints
6. A: The Holy Door into the sanctuary with Annunciation and four evangelists and the Last Supper above
B: The despotic icons with Christ or patron saint of the church to the right and the Mother of God to the left
C: North and South doors with Deacons or Angels
D: Additional optional icons

could be as many as six or seven rows (fig. 23). The Royal Doors most commonly have a representation of the four evangelists and the Annunciation, and on each side of them there would be an icon of the Virgin Mary to the left and Christ to the right; sometimes, instead of Christ, there was an icon of the saint or biblical event to which the church was dedicated. These icons are often called the 'despotic icons' or the Sovereign row. Above this row, there was either a register of the main liturgical feasts of the Orthodox church (very often twelve are shown) or the Deesis row. This was normally the grandest row with the largest icons. Christ was at the centre and the usual order was, from left to right, Peter, Michael, Mary, Christ, John the Baptist, Gabriel and Paul. In a very large church, other saints could be added to the Deesis row, usually pairs of Church Fathers or other highly venerated saints. The top two layers were interchangeable, either a row of Prophets or Patriarchs. Sometimes a crucifix was added to the top of the iconostasis. The fully developed iconostasis meant that, on entering the church, the visitor now confronted a high wall of icons, which covered the entrance to the sanctuary. To some extent the symbolism of the icons on the screen would seem to repeat – or at least re-emphasize – that of the painted figures and scenes on the walls of the church. It may have been this factor of potential repetition which stimulated the creation of new and highly detailed cycles in the wall decoration of this period, making the church walls a public encyclopaedia of Christian knowledge and allegorical church history, and the iconostasis the accessible place for individual prayer and devotion.

THE ICON OF ST PETER

The St Peter panel in the British Museum can be observed in the light of this sketch history of the making and functions of icons. It depicts the saint with greying brown hair and beard, his face turned to the right. He is wearing a light coloured mantle (*himation*) over a blue tunic (*chiton*). This was the standard form of the garments in which apostles and Christ are represented in art throughout the Middle Ages; dressing them in clothes contemporary with the time of production was avoided. He holds a scroll on which an inscription is written in Greek capital letters (fig. 24). Enough can be seen to reconstruct the Greek text, which is taken from the first Epistle of Peter, chapter 2, verse 11: 'Beloved, I beseech you as aliens and exiles to abstain from the passions of the flesh that wage war against your soul.' This text would be highly appropriate if addressed to readers who had chosen to leave public society to live in the ascetic conditions of a Greek-speaking monastery. Other paintings using the same text have been found in Byzantine monasteries, so this icon therefore was probably made and designed for use in such a setting. The identification of the saint as Peter results from the fact that he is displaying a text

24. Detail of the icon with St Peter (fig. 17)

The Greek inscription on the scroll is from the first epistle of Peter, 2:11: 'Beloved, I beseech you as aliens and exiles to abstain from the passions of the flesh that wage war against your soul.'

from his writings and that his portrait type is fairly typical of that saint, who is described in the eighteenth-century *Hermeneia* as 'an old man with a rounded beard', although back in the fourth century Epiphanios of Salamis complained that there was no justification for painting St Peter 'as an old man with hair and beard cut short'. This was a fair point as, like Christ, there is no description of St Peter in the Gospels. But visual histories can be more powerful than texts.

The panel is no longer its original size, and the saint looks uncomfortably too close to the right border. It has been cut down to its current area of 68.7 x 50.6 cm, but this is still relatively large. It is worth trying to reconstruct the original extent and shape of the panel. The original figure of St Peter was probably half length rather than full length. The size of the icon is a significant factor in any theory about its possible function in the monastery for which it was made. The panel must originally have been larger on the top and bottom and on the right, but the left edge may be original (fig. 25). What we see today is the outcome of a skilful restoration operation by Stavros Mihalarias, which was completed in 1983, the year the icon was purchased by the British Museum. From the front we can see the convex curvature of the tree, which nicely suits the turning pose of the figure. The back of the panel is not, however, original, which explains why it is so thin (8 mm). The explanation in this case is the technique of restoration: as part of the restoration process, the panel which came to the studio was separated vertically into two separate icons. This original panel was 2.5 cm thick. It is now two icons, each thinner than before.

The painting came for restoration as an icon of Christ (fig. 26). But it was noticed that the back of the panel had traces of gilding beneath a coating of whitewash and a dark layer of oxidized varnish. This side was cleaned and the image of St Peter emerged from beneath this covering (a small patch of this overlay has been retained on the left side near the bottom edge). At some time, probably in the seventeenth century to judge from the style of the image of Christ, an icon painter had decided to reuse an old panel depicting St Peter. He painted over that side, cut down the panel and used the back (now the front) for his painting of Christ. In fact he painted Christ upside down in relation to St Peter. The side with St Peter was much earlier in date than the image of Christ on the other side. After the figure of St Peter was uncovered, the two sides of the panel were separated, and only the side with St Peter is in the British Museum. We cannot know why the panel was reused in a later period. It may be that it was seen as a piece of well-seasoned old wood and so could be adapted with great speed, and without the need for a long process of preparation.

The technical aspects of the icon were examined during the restoration. The wood was identified as cedar and this wood support had been covered with gesso, then a coarse tabby linen, and then several more layers of gesso. The background was high-quality gold leaf, its colour enhanced by the thin yellow orange bole over which it was laid. This

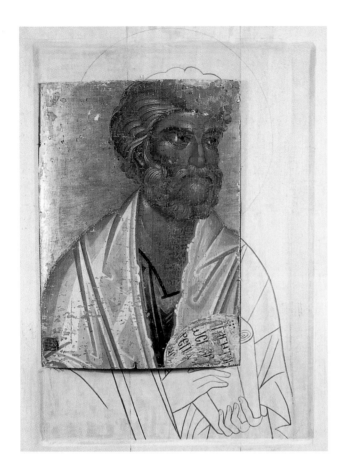

25. Suggested reconstruction (by Stavros Mihalarias in 1983) of the icon of St Peter (fig. 17) in its original form as a half-length figure

tells us that we are looking at a panel which was prepared and painted with expensive materials. The medium was tempera, as one would expect, and the paint was quite thinly laid, especially in the light areas, where it is also more opaque. Study under the stereomicroscope allowed Mihalarias to describe the order in which it was painted: the face was built up, starting from a thin green and bone brown underpaint and then with hatched strokes containing gradually more red and white lead. The highlights were off-white in thicker brushstrokes. Mihalarias viewed the painter as an artist of great virtuosity. The handling of the paint on the surface of the icon is speedy and confident. The brushwork followed the forms of the face as it did the forms of the drapery, which was painted in much thicker tones of burnt sienna. The hatching was simple and direct, and the treatment is broad in a linear style.

A close look shows that the icon has suffered a fair amount of damage over time. Its poor condition by the seventeenth century may be the reason why it was recycled and the image painted over. The surface is abraded and there is much loss of the original paint surface. But the most serious problem is the fact that the centre of the face had been obliterated at some time in the course of its history. This is such a serious loss visually that Mihalarias painted in a modern version of the lost nose, based on comparative Byzantine images. This restoration has been retained, not an uncommon procedure in museums.

The St Peter icon can only be dated on grounds of style. The best parallels seem to come from Byzantine painting of the first decades of the fourteenth century, also expressed as 'the first third of the fourteenth century'. Some of the closest stylistic connections come from the best preserved late Byzantine church in Constantinople, the Chora monastery, which since the Ottoman period has functioned as a mosque, the Kariye Camii, at least until it became a museum in the twentieth century. This restored church has both mosaics and wall paintings which can be dated from texts to the period of its Byzantine rebuilding and embellishment by one of the richest men in Byzantium, the Grand Logothete, Theodore Metochites. He acquired the property as a Middle Byzantine monastic complex and transformed it into a grander establishment between 1315/6 and 1321. The pastel colours of the garments, the firm and solid treatment of the face, and the emphatic lines in the hair link the icon of St Peter with this early fourteenth-century

Byzantine art, and with the decoration of the Chora church at Constantinople in particular. This makes it possible to contemplate the idea that the icon was by the same artist and was even made for use in this church. The main argument against this speculative attribution is that the design of the scalloped edge of the mantle does not appear in the Chora mosaics or wall paintings. However, this is an icon, not a wall decoration, and so might have been differently treated by the same artist. One question is whether the icons of a new Byzantine church were usually produced as the final pieces of work to be executed, or whether artists decorating the church worked on icons during the cold winter months when working on plaster was more difficult and not ideal technically. The attribution of the St Peter panel to the artist who painted the Chora monastery is far from certain. But he was apparently very versatile, as he was probably responsible for the mosaics in the church now known as Holy Apostles in Thessaloniki, the patron of which was the Patriarch Niphon of Constantinople (1310–14). If this is the case, the artist is notable for working with patrons who were both deposed from their high positions in the Byzantine state because of personal corruption and misuse of power.

The final question to pose here regarding the St Peter icon is whether we can determine what the function of the panel might have been in whichever monastery it was made to decorate. Its size and the expense lavished on its gold background suggest a prominent location. One therefore is bound to look at the possibility that it was a permanent icon in the church and placed on the screen in front of the sanctuary. The simplest answer would be that it was placed in the intercolumniation space of the templon screen, and as a 'despotic icon' it would be balanced with an icon of St Paul. But it is also possible that it belongs to a higher and more developed iconostasis screen and was part of a Deesis register. Both possibilities could, as it happens, be entertained in the naos of the Chora church, though the removal of the screen during its time as a mosque adds to the problems of its reconstruction. What we see in the church today are two grand, specially framed mosaic icons of the Virgin (on the right pier) and Christ (on the left). The sanctuary screen might have been aligned with them or set back along the step into the sanctuary. There can be no sure conclusion about the church for which St Peter was made, but the exquisite decoration which survives in the Chora church does at least explain the kind of setting within which the British Museum's St Peter was once venerated as a major icon.

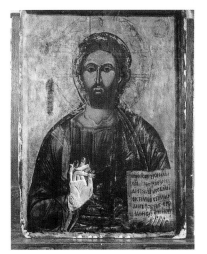

26. Icon with Christ

Post-Byzantine, seventeenth century. 68.7 x 50.6 x 2.5 cm

This bust figure of Christ holding a Gospel Book and with his hands revetted with metal covers was brought for restoration to Stavros Mihalarias, who discovered that it was a re-used and cut-down cedar panel; on the back was uncovered the icon with St Peter (fig. 17).

Reading icons

Every work of art that we call an icon was produced in a Christian world for a Christian audience. While Christianity is certainly a religion 'of the book', once iconoclasm was defeated the principle was established among thinking Byzantines that the promotion and understanding of the faith must use imagery as much as words. The most articulate intellectual who lived through iconoclasm, Photios, who later became the Patriarch of the Orthodox church, made the point in his public sermons. He insisted on the importance of the visual in his Homily XVII, which was delivered in the church of St Sophia at Constantinople probably on 29 March 867. That day marked the celebrations of the inauguration in the apse of St Sophia of a new mosaic of the Virgin and Child, which still decorates the church today (fig. 28). It was the first figurative mosaic decoration to be set up in the church after the end of iconoclasm, and it must have made an amazing impact on a generation that had not grown up with churches filled with images. Photios asserts that seeing the imagery of Christ makes it easier to accept the truth of his incarnation in the flesh than merely reading the Gospel accounts: 'Christ came to us in the flesh and was carried in the arms of his mother. This is seen and confirmed and proclaimed in pictures, the story is made clear by means of our personal eyewitness and viewers unhesitatingly accept this truth.'

The world in which icons were produced and viewed was one in which everyone had knowledge of the Bible and of medieval Christian devotional literature, and looked at icons with this awareness always at the front of their minds. Whenever Photios (or any other priest) wrote a homily, it would be full of direct quotations from or indirect

27. Ivory with an archangel

Byzantine (Constantinople), 527–65. 42.8 x 14.3 x 0.9 cm
British Museum

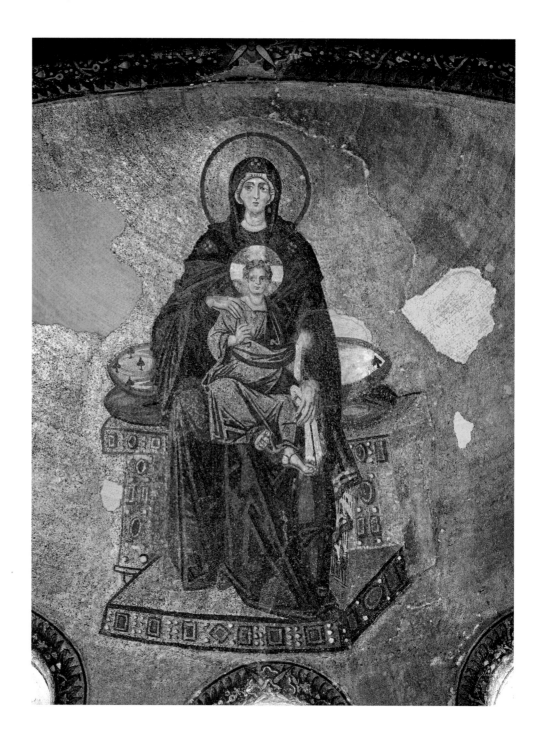

28. Mosaic with the Virgin and Child between archangels

Apse of the church of St Sophia, Istanbul. Inaugurated on 29 March 867 with a homily from the ambo by Patriarch Photios.

The sutures in the gold mosaic background reveal that this imagery replaces the original cross of the sixth-century apse decoration; the redecoration of the church with figural mosaics to celebrate the defeat of iconoclasm (843) started in the apse.

references to Christian writings. For us these sermons may sometimes seem to be almost pastiches of passages from the Bible or the Fathers, but to the priest and his audience, these words and phrases were both evocative and also guarantees of proper Orthodox thinking. We have to learn to appreciate their acquired skills of patristic exegesis before we can begin to pick up all the associations they found in texts and pictures. For them scripture edifies the reader because it is divine revelation. If the four Gospels give different accounts of the same events, the medieval viewer took the opportunity to reflect on the full story, and did not ask which version was the more correct. Although text was crucial to everyone's thinking and considered the source of one's moral life, education was not widespread. Even if few in Constantinople could read, the whole congregation of St Sophia could listen to sermons and reflect on their meanings. Photios saw to it that his literary achievements also became available in manuscript form to those few who collected books or visited the Patriarchal library. There were, it seems, few private libraries in the Byzantine world, and even those probably numbered their holdings in dozens rather than hundreds. Michael Attaleiates, senator and judge in the eleventh century, recorded his library in March 1077: there are only a few dozen books, nearly all biblical or spiritually elevating, such as commentaries by the Fathers, saints' lives or service books.

One of the most popular books of the Middle Ages, already mentioned in chapter one, was the Heavenly Ladder of St John Climakos (see fig. 11). This book was read aloud in monasteries during Lent and so must have become a very familiar text to monks, even to those who could not read. The book relates the monastic virtues; obedience is predictably given special emphasis. The text is full of edifying moral discourses or statements such as 'the Fathers have declared the singing of psalms to be a weapon, prayer to be a wall, and honest tears to be a bath. To them, blessed obedience is confession of faith, without which no one subject to passions will see the Lord.' One soon learns from reading sermons and the everyday literature of the monk – and no doubt that of the ordinary person – what a serious world of moralizing and edification has to be assumed for the Byzantine viewer. The icon serves this environment well, though we are wrong to conclude that there was no humour or subversive thinking in Byzantium. But we must expect the Byzantine viewer in front of an icon to absorb the imagery in the light of their prior textual knowledge.

Two early ivory panel icons in the British Museum may point up some of the differences between our viewing and their viewing. One of these is the largest known ivory panel from Constantinople and depicts an archangel (fig. 27). Its style and technique suggests that it was made sometime in the reign of the Emperor Justinian I (527–65) when other similar naturalistic ivories were made; best known is the so-called chair of Bishop Maximian at Ravenna which was perhaps designed to hold a Gospel Book in the sanctuary of a church rather than to seat the bishop whose monogram it carries. The

archangel, though naturalistic in appearance, hovers in front of the architecture rather than standing firmly, perhaps an intentional reference to the fact that the archangels are known as the incorporeal ones. Later, probably in the seventh century, a text was written on the back of this ivory, most likely a prayer or a liturgical text. Such texts were often added when early ivories were reused in medieval churches, sometimes giving the names of those to be commemorated in the liturgy. This ivory was almost certainly one of a pair, in this case the right wing of a diptych. The archangel holds a sceptre and a jewelled orb, which are fairly regular attributes of the archangels Michael and Gabriel, though the question arises whether they might have a special meaning here. The grandness of the ivory has led to the suggestion that it might have been commissioned to celebrate the accession of Justinian in 527, and that he was actually represented on the left wing accepting his royal symbols. The text – of which we presumably have only the second half – might have established the meaning of the diptych. As it is, the Greek verse inscription is highly ambiguous; it is an iambic trimeter, probably a quotation from some text yet to be identified. One translation is 'Receive the suppliant before you, despite his sinfulness'; another is 'Accept the present circumstances, even understanding their essence', and yet more are possible. The problem with this icon is that it is clear that text and image combined to give a specific meaning, but we have lost the full information necessary to unravel that. We are left with a monumental figure of an archangel in an ivory icon whose original significance eludes us. Many art historians have identified the figure as the archangel Michael, the angel of death.

Another ivory from this period may seem at first sight easier for a modern viewer to approach, although it is much less sophisticated in its carving and workmanship. The first thing to notice about this ivory (fig. 29) is that it is very direct in its imagery. The upper section is symmetrically composed: at the centre is the Virgin Mary, staring straight out at us, with Christ on her lap, equally frontally represented. The two figures dominate the panel and catch our attention first – as images they work like the cult statues of pagan antiquity. Frontality helps to elevate the status of the figure and encourage the viewer to awesome submission. The Virgin and Child hardly relate to each other at all, but make direct eye contact with the viewer. In this respect the ivory is a devotional panel, and one that can be used for the expression of prayers. It is an aid to prayer; the viewer will address their unspoken words to the Virgin and hopes that she will be an intercessor to God the Father, supported by her maternal relationship to Christ. The viewer knows that they are mother and child, but the visual devices ensure that they cannot be seen as an ordinary family, for Mary and her son are seated under a ciborium on columns. This was a special kind of structure found in the sanctuary of the Byzantine church, set up over the holy altar. This compositional feature helps to emphasize the theology that resides in the iconography: the birth and biblical incarnation of Christ must also evoke his death, his preordained sacrifice through the crucifixion.

Reading this ivory in such terms is, however, only half correct. The viewer is certainly meant to think of the Incarnation but it is not actually the scene depicted. To the left of the Virgin is an angel with a sceptre capped by a cross. This angel introduces to the Virgin and Child three visitors, who wear Persian caps. They are the three Magi, and the scene is therefore the Adoration of the Magi at the time of the Nativity of Jesus. Their symbolic and theological role is as historical witnesses and believers in the divinity of the child. The ivory includes an extra set of imagery in the small frieze below the main composition. On the left is Joseph, who is normally present in representations of the Nativity, as are the animals in the stable where the birth took place (always seen as a cave in Byzantine art, replicating the identification of a cave at Bethlehem as the true location of the event, over which the church of the Nativity was built in the fourth century). The child is in the manger, wrapped in swaddling clothes, and the figure of a woman is seen kneeling and holding her hand out towards Christ. This is a representation of the doubting midwife, whose rejection of the divinity of Christ caused her hand to be paralysed and wither. But she was cured when she repented and held out her hand to Christ. This too is a story of the acceptance of the true nature of Jesus. But it comes not from the canonical four Gospels as accepted by the church, but from the Apocryphal New Testament books, which were already circulating in the Christian world by the second century. Texts such as the *Protevangelium* or Book of James filled in many details about the life of Mary and her childhood in the temple which are entirely missing from the accepted Gospels. Although the church officially did not recognize these texts as genuine, Byzantine perceptions of Mary and the life of Christ were coloured by them, and artists incorporated such events as the story of the midwife into their icons.

This ivory is said to have come from a monastery in Thessaly in North Greece and to have been framed for use as an icon. Art historians have felt that its style and quality might mean that it was carved in Syria or Egypt in the sixth century, but this idea may depend too much on a comparison of it with the high quality work of the archangel ivory, which is universally attributed to Constantinople. One of the problems of the early Byzantine period is that the role of Constantinople in the formation of style cannot be

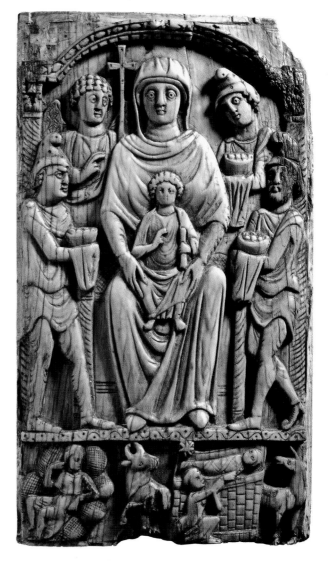

29. Ivory with the Madonna

Byzantine, sixth century.
21.7 x 12.4 x 1.2 cm
British Museum

documented from what survives from that city. It is clear enough that all the cities and regions of the Mediterranean world were actively commissioning church building and Christian art, but how far artists worked in local styles at local centres or moved around the empire is not documented. By the time of Justinian, Constantinople was becoming politically dominant as the centre of the Roman empire, and that may have attracted the best artists to work there, and also to accept work from other parts of the empire from time to time. But more likely there were all levels of expertise both in Constantinople and in the regions of the empire. What matters more in looking at these ivories is to recognize the visual strategies involved in each. The production of every icon depended on the expertise of the artist in using the best means to communicate the meaning of the imagery. At the same time, each icon had its particular function at the time of commission, if it was specially made for a patron, but a more generic function if it continued in use in later centuries. It must have been a feature of Byzantine churches that they contained both icons made for specific members of the congregation at a special moment in time and examples made perhaps centuries earlier which had gained an aura of sanctity. Both these icons had an afterlife in the later Middle Ages, which meant that they functioned in new settings in different ways than at first intended. Thus any icon that we study today has various levels of meaning, both specific for the donor and general for the public viewer. Icons, like the text of the Bible, were continually open to religious interpretation and commentary.

Centuries later than the ivories, one painted icon in the British Museum, the icon with four church feasts (fig. 30), raises issues regarding production and viewing in the fourteenth century. It helps us to see what the differences and similarities are between the sixth and fourteenth centuries. Historically the differences are massive. In the sixth century the age of Justinian was one in which the Roman empire appeared to have been revived. The armies of the eastern emperor had reconquered Italy and North Africa and the flourishing artistic culture of Rome and Ravenna reflects this new situation and optimism. Justinian aimed to establish a renewed Christian Roman empire, with a centralized law code, administration and united Orthodox church. Church Orthodoxy was defined by the decisions of various ecumenical councils attended by all bishops. The Byzantine church accepted that the cumulative decisions of the seven councils from the fourth century to Nicaea in 787 constituted true Orthodox doctrine. In the sixth century there was still considerable disagreement and heresy in the air. Although many of the initiatives of the reign of Justinian were successful – the court historian Procopios praised the military and artistic achievements of the emperor, although he could not refrain from criticizing many aspects of the regime in his *Secret History* – the later sixth century was a period of increasing crisis. The eastern Roman empire of Constantinople could not militarily hold onto its possessions and new hostile threats came from the movements of Slavonic tribes into the north and the Balkans and the revival of the Persian empire in the east. Worse

30. Icon with four church
feasts from the Gospels:
the Annunciation, the Nativity,
the Baptism and the
Transfiguration

Byzantine (Constantinople
or Thessaloniki), c. 1310–20.
38 x 25.6 cm
British Museum

31. Details of mosaic with the Deesis (Prayer)

South Gallery of St Sophia, Istanbul, probably 1261.

In the Deesis mosaic the Virgin (left) offered the prayers of mankind to Christ (right). It was a large devotional panel in a small oratory. The mosaic marked the redecoration and conversion of St Sophia back into an Orthodox cathedral after the end of the Frankish Kingdom of Constantinople (1204–61).

was to come politically in the seventh century with the rise of Islam and the rapid expansion of an Arab empire across North Africa and in the Middle East. The contraction of the Christian Roman empire coincided with iconoclasm in the eighth and ninth centuries. The tenth and eleventh centuries marked a change in the fortunes of the Byzantine empire, but despite the military strength of the Macedonian dynasty of emperors (867–1056) the extent of its power was never again as geographically broad as under Justinian, and Constantinople was the centre of power and influence. The next dynasty, that of the Komnenoi, lasted from 1081 to 1185, and had to operate in the shadow of two major threats to its security. The first was the emergence in Asia Minor of the Seljuk Turks, whose power was shown by their ability to defeat the Byzantine army at Mantzikert in August 1071. In due course it was the threat from the Islamic Turkic invaders that was to culminate in the capture of Constantinople in 1453 by the Ottoman Turks. The second threat was that of the Crusaders. The First Crusade was declared by Pope Urban II on 27 November 1095, and the arrival in the Levant of western armies, who rapidly captured Jerusalem from the Muslims, was a mixed blessing for the Byzantines. The Komnenoi tried to manipulate the Franks and to share territories with the new Latin Kingdoms, but in the end the armies of the Fourth Crusade turned their hunger for

possessions onto Constantinople and from 1204 until 1261 it became the capital of the Latin Kingdom of Constantinople. Many of the Byzantines moved out of Constantinople and went to Nicaea, Trebizond and other parts of their previous empire.

The Crusaders gained several significant new possessions, notably islands and much of Greece. The Venetians were particular beneficiaries of the new situation, and took the opportunity to remove artistic treasures and Christian relics from Constantinople in order to enhance the imperial status of Venice itself. One outcome of the occupation of Constantinople in 1204, then, was the looting of its material and cultural history. Another was the intensification of the tensions between eastern and western Christianity. In ecclesiastical terms the churches of Constantinople and Rome had entered into schism in the year 1054. In this year Cardinal Humbert came to Constantinople and excommunicated the Greek Patriarch Kerularios when he refused to accept the claim of Pope Leo IX that Rome was the head and mother of the churches. But it is not clear how seriously this excommunication was taken (and in 1965 the Pope and Patriarch agreed to nullify the anathemas). What one cannot deny is that throughout the Middle Ages there were underlying religious and political tensions between the Latin west and Greek east, in part the consequence of thinking in a different language. The sack of Constantinople aggravated these tensions, especially when St Sophia was converted into a Latin cathedral with the imposition of a Latin Patriarch. The situation changed when the Byzantine emperor Michael VIII Palaiologos recaptured Constantinople in 1261 and re-established a Byzantine empire. The final dynasty of Byzantium was the Palaiologan family (1261–1453) and politically they realized that an alliance with the west might be the best way of resisting the advance of the Islamic Turks. They therefore initiated two councils with the Catholic church and the Union of Churches was twice declared (at Lyons in 1274 and at Florence in 1439), but this reconciliation was unacceptable to the majority in the Orthodox church, and was formally and finally rejected at the Synod of Constantinople of 1484.

In looking at icons it is necessary to recognize the 'love-hate' relationship between eastern and western Christianity. This explains why the icon is not an art form limited to Constantinople alone, as can be seen from the fact that Rome was as interested as Constantinople in claiming possession of icons of the Virgin Mary painted by St Luke. Both spheres of Christianity had the same structure of the liturgy, church year and ritual. Both were knowledgeable, more or less, about the literature and art of the other, and there are many similarities in their art, particularly in the thirteenth century when contact was so close. Whereas Giorgio Vasari in the sixteenth century built up a picture of distance and difference between Giotto and Duccio and other Trecento artists, the fact is that we can see all sorts of similarities and contacts. The famous Deesis mosaic in St Sophia (fig. 31), which most likely dates to the redecoration of the church on its return to Orthodox use in 1261, represents the face of the Virgin Mary in a soft and naturalistic style that matches the Madonnas of Giotto and Duccio in Florence in the 1280s and later.

The conclusion must be that there is a connection between the art of Constantinople and that of Italian cities like Florence, Siena and of course Venice. In part the artists were working along parallel lines, in part they must have been directly emulating each other. This mutual contact between east and west is a feature of all icon painting of the Palaiologan period, but it works out in a complicated way. As the art of the Italian Renaissance developed a distinctive character, stimulated by innovations such as the refinements of pictorial perspective or the development of new effects through the use of the oil medium, it seems clear that the most conservative Orthodox icon painters rejected many of these features in order to retain their traditional Byzantine methods. But this is only a very broad view of the later development of the icon, and these questions will be re-examined in chapter five.

THE ICON WITH FOUR CHURCH FEASTS

The British Museum's icon with four church feasts displays four well-known Gospel scenes. When it arrived from Egypt in 1851, it was in two separate parts. It came from the monastery of the Syrians at the Wadi Natrun and belonged to a church dedicated to the Virgin Mary. Although O.M. Dalton, a curator at the British Museum and the first to study the icon in 1909, thought it was painted in the twelfth century for a sanctuary screen, it is now clear that it fits in style with church decorations of the early fourteenth century. In particular it is similar in its stylistic manner with the wall paintings of the small church of St Nikolaos Orphanou at Thessaloniki (fig. 32). There is good reason to date that church between 1310 and 1320 when other churches in Thessaloniki and its region were decorated in a similar style (notably the church of Holy Apostles at Thessaloniki, which can be dated to 1310–14 as part of the work of Patriarch Niphon, though this is controversial, and the church of Christ at Verria; 1315).

The Annunciation scene in the icon (fig. 33) also needs to be compared with an early fourteenth-century miniature mosaic of the Annunciation in the Victoria and Albert Museum (fig. 34). Both compositions share a particular kind of interest in perspective. This is not to use the buildings as a way of constructing a unified pictorial space by means of a single vanishing point. Instead the lines of the architecture lead the eye towards the two figures in the foreground: Gabriel to the left and the Virgin standing in front of her house at the right. In differing ways the artists are concerned to suggest the downward movement of the angel to announce 'You shall conceive and bear a son, and you shall give him the name Jesus' (Luke 1:26–38), and to show the surprise of the Virgin, who is spinning thread. Both images have the iconography of the ray of the Holy Spirit coming down from heaven. They use rich bright colours and gold: gold leaf in the icon and gold tesserae in the micromosaic. The dating seems secure, but the icon's place of production is hard to ascertain. The technique of micromosaics seems to have been a speciality of the artists of Constantinople; it was an art form favoured in the Palaiologan

period, and the delicate pieces were later a popular collector's item in Renaissance Rome. The V. & A. mosaic was purchased in Italy in 1859. The icon with four church feasts was acquired in the nineteenth century in Egypt, but is very unlikely to have been painted there; Constantinople and Thessaloniki are more likely places of production.

Debates about the provenance of Byzantine icons are often unsatisfactory, and the collection in the monastery of St Catherine's at Sinai is a case in point. All the members of this monastic community must have come from other parts of the world. It seems likely that icon painters did work at the monastery, but would also have worked elsewhere. An ambivalent piece is the twelfth-century icon of the Heavenly Ladder of St John Climakos (see fig. 11). The patron would seem to be Antonios, who is represented about to enter heaven, and the inscription can be interpreted as meaning he was the abbot of the monastery. But was the icon commissioned in the monastery or was it sent from elsewhere, from Constantinople for example? In answering that question the evidence of another icon in the monastery is relevant. This too dates from the twelfth century, and has been attributed by art historians to the same artist as the Heavenly Ladder icon. Its style shows that the artist was expert in working in a popular style of the late twelfth century, in which all the figures are highly animated: the archangel literally swoops down from heaven. The artist might have learned to work in this style in Constantinople, but it is found widely, from North Russia at Novgorod to Monreale in Sicily. Equally the icons might both have been commissioned from Sinai, then painted in Constantinople and transported to the monastery. However, there is a good case for attributing their production to Sinai itself, as there is reason to think that in the twelfth and thirteenth centuries other artists were working on site there.

Comparing the icon with four feasts with other Byzantine works demonstrates that in stylistic terms it is a high quality work of its period which would have been appreciated by viewers wherever it was seen in the empire. Its small size and miniature quality means that it was best observed from a close position. Similar quite small sets of festival pictures in two zones are found at Sinai. Probably such two-zoned sets were intended to be portable, perhaps for liturgical use (maybe for setting up on an altar). One question, then, is whether this icon is complete or originally was part of a larger set. The four scenes

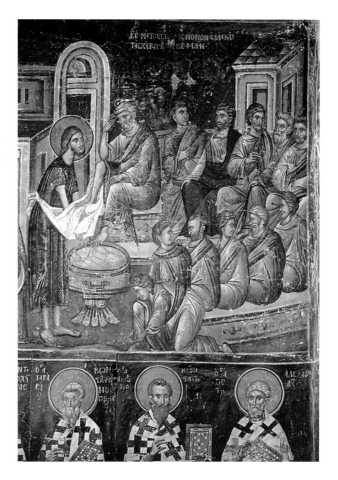

32. The Washing of the Feet (detail from fresco)

Byzantine, c. 1310–20.
Church of St Nikolaos
Orphanou, Thessaloniki,
Greece

33. Detail of the icon with four church feasts (fig. 30)

The Annunciation (*Evangelismo*) is described in Luke I:26–38 and celebrated on 25 March. The inscriptions record the names of the archangel Gabriel and Mary as Mother of God; they stand outside a building shown in perspective, with the Virgin standing up in surprise from her chair at the announcement of her impending birth. She often holds a distaff alluding to the apocryphal legend of her spinning and weaving the priests' vestments in the temple of Jerusalem.

are the Annunciation, the Nativity, the Baptism and the Transfiguration; each is given its title in Greek. This in fact makes a very good ensemble, which Rowena Loverance has noted forms a theological unit of the Incarnation and so comprises a neat homogeneous group. It shows the early life of Christ up to the significant turning point of the Transfiguration (the *Metamorphosis*; fig. 35) when his divinity was made manifest on Mount Thabor in Galilee to three of the apostles, Peter, James and John, who were dazzled by the shining white light, and acknowledged by the two major prophets of the Old Testament, Moses and Elijah, who converse with Christ. The theological significance is that the Old Testament law is thereby recognized as having been superseded by that of the New Testament. The image is an allegory of the supremacy of the Four Gospels conveyed through a historical event recorded in the Gospels. In these four scenes, Christ appears four times – as a baby in the manger in the Nativity on whom a ray of light shines from heaven; then in the scene of the first bath with the two midwives (one prepares the water, the other holds the child); thirdly as a naked figure standing in the river Jordan at the time of his baptism by St John; and finally in shining clothes, surrounded by a mandorla, at the time of the Transfiguration. A good example of these scenes being treated as a set is to be seen in the twelfth-century monastery church at Daphni near Athens, dedicated to the Virgin. It was precisely these four scenes which were chosen for display in the four architecture units (squinches) which surround the dome. This icon might therefore have been a complete thematic unit in its current form, and its portable function might explain how it ended up in Egypt.

How might a fourteenth-century Byzantine have viewed this icon? Here we are hampered by the almost total absence of texts in which anyone recorded their ways of seeing. There are some collections of primary sources, notably by Cyril Mango (1972) and Hans Belting (1994), and these are very useful for bringing together a number of key passages (in English translation) which show us how the Byzantine elite (such as the Patriarch Photios) wrote about art and architecture. But there is virtually nothing in the surviving texts to indicate what their immediate response to an icon might be.

34. The Annunciation. Mosaic with tesserae of gold, silver, lapis lazuli and semi-precious stones in wax on wood

Byzantine (Constantinople), c. 1320. 13.3 x 8.4 cm Victoria and Albert Museum, London

Considered as a series of festival scenes, this icon shows the Annunciation (25 March), the Nativity (25 December), the Baptism (first of the seven sacraments) and the Transfiguration (6 August). So it is clear that the ordering of the scenes does not follow the church's annual liturgical calendar. Instead the series of events in the life of Christ follows the narrative order of the Gospels. This means that our set of images, or an icon that shows the twelve major feasts of the year (the so-called *Dodekaorton*), does not represent a liturgical calendar of the year, but rather reminds the viewer that through icons one can meditate on the meanings embedded in the life of Christ, commemorated every time the liturgy is celebrated in the church. This is because the Eucharist is a symbolic re-enactment of the witness of the New Testament to the events of his life and to their meaning for Christianity. This function of icons can be approached through a certain kind of Byzantine text, the theological commentaries on the symbolism of the liturgy. An example is the sixth-century *Mystagogy* of Maximos the Confessor, soon followed by the even more popular eighth-century commentary attributed to Patriarch Germanos, entitled *Ecclesiastical History and Mystical Contemplation*. The thinking found there was in turn expanded by the late eleventh-century *Protheoria* of Nicholas and Theodore of Andida, which reads as a much more systematic discussion of the theory that the sequence of the liturgy depicts the life of Christ from the Incarnation to the Ascension. The text gives a good insight into how festival icons might have supplemented the experience of viewers at the liturgy:

35. Detail of the icon with four church feasts (fig. 30)

The Transfiguration (*Metamorphosis*) shows Christ in a mandorla between Moses and Elijah with the three apostles Peter, James and John falling prostrate before the vision of Christ in his divine nature.

Many who exercise the priestly office know and profess that what is accomplished in the Divine Liturgy is a copy of the passion, burial and resurrection of Christ our Lord. I am unable to say, however, why they are ignorant (or so they seem to me) that the liturgy also denotes all the manifestations which accompanied his entire saving life among us in the flesh: his conception, his birth, his life in the first thirty years, the activity of his precursor, his public debut at his baptism, the choice of the apostles, and the three year period of miracles which roused envy and led to his crucifixion.

This commentary was still read and known in the fourteenth century, though as it remained a popular form of literature among theologians there were new revised and extended commentaries on the liturgy written in the fifteenth century by Nicholas Cabasilas and Symeon of Thessaloniki. The most likely Byzantine viewer for the icon with four church feasts was either a priest or a monk, and it is not surprising therefore that it came to the Museum from a working monastery in the nineteenth century. If it was made for church use, it was a very special donation, since it is minutely executed in rich, bright colours with gold leaf for the highlighting. But it uses the standard compositional types of the period. Although the three apostles are in striking and dramatic positions, this was a common scheme and enhancement of the traditional iconography in the fourteenth century.

There was further motivation for developing Transfiguration iconography at this time. In other icons too we can note a new emphasis on the intense and mystical moment when the face of Christ shines with light, his garments dazzle and he is surrounding by an amazing glowing mandorla. There may be a connection with a spiritual movement of the fourteenth century, particularly prevalent in monasteries, known as Hesychasm. The ambition of the hesychast monk was to see the divine light of Mount Thabor. One method of meditation was the constant repetition of the 'prayer of the heart', the Jesus prayer: 'Lord Jesus Christ, Son of God, have mercy on me.' Icons were no doubt used to help achieve this mystical ambition, as a way of visualizing the light of God.

Saints

The majority of icons in the British Museum's collection represent as their main subject the saints of the Orthodox church. These are often called 'portrait icons' to distinguish them from narrative icons which tell the stories of the Gospels and thereby symbolically represent Christian belief. Perhaps most of the thousands of icons in existence belong to the category of portrait icons of saints, although probably the most frequently represented figure in Orthodox art is the Virgin Mary. Her portrait was believed to have been recorded from life by the evangelist St Luke, and the original could be visited at the Hodegon monastery at Constantinople. But it does not follow that images of her were treated as genuinely 'lifelike' records of her appearance. What mattered in a portrait icon was for the saint to be clearly recognizable and this was commonly achieved by labelling the saint with their name, as can be seen in the fourteenth-century St John the Baptist or the seventeenth-century Cosmas and Damian (see figs 36 and 60). Since portrait icons were meant to be lasting images which could be used for display and devotion in the church or the home for decades, if not centuries, what mattered was the avoidance of overly specific and ephemeral references to time or place. The figures and their settings and attributes in icons are intended to be identifiable, not realistic.

Byzantine texts offer a number of stories of how portrait icons were made legitimate. One such example appears in the eleventh- or twelfth-century life of St Nikon the Metanoeite of Sparta. An artist in Constantinople is commissioned by a Peloponnesian patron to paint an icon of St Nikon, who has just died in Sparta around the year 1000

36. Icon with the Prodromos (St John the Baptist)

Byzantine (Constantinople), c. 1300. 25.1 x 20.2 cm
British Museum

on 26 November (which became his feast day). The artist is given a verbal account of the appearance of the saint: his features, the colour of his hair, the character of his garments. Working on the icon at home, the artist finds it difficult to turn the verbal description into a painted portrait. Suddenly a monk enters his house. He is tall, a hermit wearing an old garment, with black unkempt hair and a black beard, holding a staff surmounted by a cross. On discovering the artist's problems in painting the icon, the visitor says: 'Observe me, brother, for the man to be painted is in all respects similar to me.' The artist turns back to the panel to find that, miraculously, the likeness of the visitor is impressed on it, and the visitor has vanished. The artist quickly finishes the painting and takes it to his patron with the full story. This only convinces Malakenos still more that the icon is a true likeness of a saint full of divine grace.

The British Museum's St John the Baptist (fig. 36) is an exquisite example of a refined Byzantine portrait icon. It is small, and has suffered damage from woodworm and there is a split in the wood running vertically through the whole figure. On the basis of style this icon can be said to have been painted around the year 1300, probably in Constantinople. Despite the damage, it is a powerful image. The icon painter prepared the panel with a raised framing border and the background is gold leaf over layers of gesso and linen. The saint is clearly identified in red letters in Greek (St John on the left of the head and 'Prodromos', the forerunner of Christ, on the right). He blesses the viewer with his right hand and holds a rolled scroll in his left. John is regarded in the Byzantine church as the last and greatest of the Old Testament prophets, and his main role was to live as a hermit and preacher in the desert and to baptize his disciples in the waters of the river Jordan. He is generally represented wearing a camel-hair tunic, and he is for the same reason usually shown as emaciated and unkempt: a man of the wilderness. This icon differs from the stereotype. He does have appropriately unruly hair and a long beard, but he is wearing an elegant green mantle (himation) with blue shadows over a reddish-brown tunic (chiton), also with blue shadows. Only by looking closely can one see the top of a hair shirt beneath the tunic. His expression is calm and authoritative. In all he is a noble, almost Christ-like, figure. His facial features do not offer a recognizable or distinctive portrait: he has full lips, a long nose and widely set eyes, and is of fairly indeterminate age (but without grey hair). The rich colouring of his garments and the way he looks dramatically out of the gold background add a touch of the sublime. What is therefore striking about the icon is that one knows without doubt that this is a figure of St John the Baptist, but it differs from many other images of this saint, and particularly from another icon in the Museum's collection which was painted on Crete and shows him in the desert and with wings (see fig. 59).

The richness of this small icon is one of the reasons for attributing it to Constantinople, but there are no clues as to whether it was intended for a church dedicated to John the Baptist (of which there were around twenty-six in Constantinople) or made

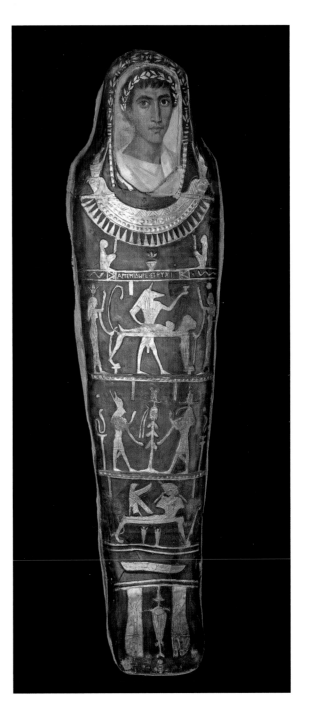

37. Mummy case and portrait of Artemidorus

Hawara, Egypt, AD 100–20.
171 cm long
British Museum

The mummy case is red painted stucco with Egyptian funerary scenes; the inserted portrait panel is in encaustic on wood.

for private devotions in a monastery or home. John was both a popular birth name in Byzantium and a name that a hermit or monk might choose when he was accepted as an ascetic. As an intercessor with Christ, this icon of St John would be excellent as an aid to prayers for salvation.

The popularity of portrait icons of the saints such as this one, if considered as historical testimony, may be treated as one clue to understanding the nature of Orthodox culture and attitudes. In a sense it is also true that this type comes closest to the loose modern use of 'icon' to mean a charismatic personality. These portrait icons also take us back to the origins of Christian art, for noteworthy attention was given to portraits of charismatic leaders and heroes in the Roman empire. Although no Roman *imagines* (wax portrait masks of those who held the higher political offices) actually survive from antiquity, there is good evidence to suggest that such masks were displayed in shrines in the home and were worn by figures dressed up as the dead at public sacrifices and family funerals. These practices in honour of the ancestor continued into the late empire and were part of the world in which early Christians lived. They indicate why the production of icons of martyrs and charismatic Christian saints was an attractive addition to the Christian environment. But the familiarity of early Christians with portrait icons was even more universal than the cult of noble ancestors. Portraits of both famous and everyday inhabitants of Pompeii are to be found in the wall paintings on houses there. The evidence from the Fayum in Egypt is of a continuing tradition in late antiquity of the production of Roman family portraits. The British Museum has a major collection of these Fayum portraits, including some still attached to mummies.

Such panels, in wax encaustic or tempera, are important for the study of the icon in various ways, as not only do they provide evidence of the history of portraiture, they also show techniques of painting used in icons and give information about the nature of panel painting in antiquity. Our knowledge of Egyptian production of these paintings derives in the most part from exploration in the region by the Viennese antiquarian and dealer Theodor Graf, who found around three hundred pieces in 1887 and subsequent years, and from the more systematic excavations undertaken in 1888–9 and 1911 by Sir Flinders Petrie at the Roman cemetery of Hawara, where he found 146 mummies with portraits. The Museum has some eight panels from the Graf collection and around twenty from Petrie's excavations, including the early second-century portrait of Artemidorus, still attached to the mummy (fig. 37). The dating of these panels depends on the indications of style, and the sequence seems to run from the first century AD up to the fourth century. A common presumption is that the rapid spread of Christianity in Egypt and the consequent interment of the dead in their everyday clothes probably caused the abandonment of mummification and the termination of the business of producing specially designed portrait panels to fit into the casing of the mummy.

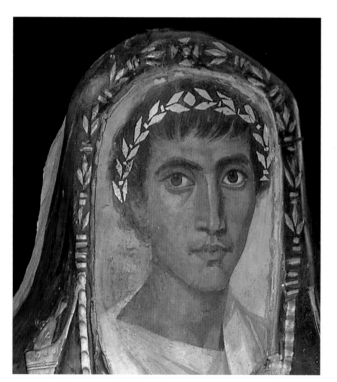

38. Detail of the portrait panel of Artemidorus (fig. 37)

Recent research in the Museum on the mummy of Artemidorus has given a number of new pieces of information which are pertinent to interpretation of the painted portrait panel. The mummified body is still inside the red painted stucco casing. The face is painted on a thin lime wood panel in encaustic, and below the panel is a falcon collar and a set of traditional funerary scenes, such as the uppermost one where the god Anubis attends the mummy, which lies on a lion-shaped bier flanked by goddesses (probably Isis and Nephthys). Just above this scene is a (badly spelled) inscription in Greek: 'Farewell, Artemidorus.' The mummy in all shows a striking merging of Egyptian funerary art, a Greek name and a Roman portrait type. Looking at the body inside the mummy, it was discovered from CT scans that the bones around the nose and at the back of the skull were damaged. Either this damage was done in the course of a rough mummification or it may indicate the cause of death. The analysis suggested an age at death of between eighteen and twenty-one.

What is interesting about this kind of information is whether the panel was a likeness of the corpse inside the mummy. In the portrait we see a naturalistically painted face with a gold wreath of leaves and berries across the hair and another on the casing around the panel (fig. 38). The

features are strongly characterized and certainly distinctive. But it does not follow that this is a realistic and lifelike portrait of Artemidorus at the age when he died. It may be a generic portrait type that only hints at his actual face and features. When it comes to portraiture, naturalism and realism are two different concepts. There is a great gulf, for example, between the faces on the Fayum panels and the extraordinary lifelike and personally revealing portraits painted by, for example, Hans Memling at Bruges in the fifteenth century. One difference too is that the purpose of the Fayum portraits was to decorate the mummy after death and to commemorate the dead, whereas Memling was making portraits for his patrons to keep in the home.

Since the Fayum portraits were designed as funerary art, it is not easy to see them as the direct antique source for the development of the Christian icon, as is sometimes proposed. Yet it is true that the technical procedures and materials used in the mummy portraits are very similar to those of the earliest extant icons, dating from the sixth century and onwards. This poses the question of how far the icon is a continuation of pagan Graeco-Roman art. Fortunately recent research, particularly in Egypt where the dry climate favours the preservation of such materials, has set out a good deal of new information about other forms of pre-Christian painting. A number of surviving pagan panel paintings (*pinakes*) show the full range of ancient art that is relevant to the issue of the icon's origins. These ancient panels come in various forms – individual framed pictures, pictures with sliding lids, and triptychs – all forms which are also found in the early icons at St Catherine's monastery, Sinai. The ancient panels have a diversity of functions, types and subject matter, including pagan gods and military figures; there are also portraits of Isis, the mother goddess of Egypt, who sometimes appears enthroned, as does the Virgin in the early Christian icons.

It is therefore clear that the icon is not an original and distinctive 'invention' of Christian art, but is an art form with a history which connects with funerary, domestic and religious panels, as well as works in other media. The interior of an ancient sarcophagus from Kerch, now in the Hermitage Museum at St Petersburg (fig. 39), even carries a representation of an artist at work on a panel painting in his studio. This all gives evidence of continuity with antiquity, but also of development and difference. For example the use of icons in the Orthodox church, which intensified with the development of the templon screen and the iconostasis, cannot be matched in the pagan temple, where most ritual took place outside the building, with a cult statue in the interior. Another basic difference is that the pagan deity was an inaccessible being, whereas all the figures in Christian icons have flesh and blood prototypes; the icons act as a reminder of that prototype, now in heaven and an object of reverence. The Orthodox Christian lived in a world inhabited by saints who were invisible, yet made manifest in dreams, visions and icons.

The importance of the saint in Byzantine and Russian culture is reflected by the preservation and veneration of so many of their relics. Perhaps in the modern world it

39. Sarcophagus interior with painting of an easel artist in his workshop

Bosporan Kerch (ancient Panticapaeum), northern Black Sea, c. AD 100. Found 1900; now in the Hermitage Museum, St Petersburg

This image of an artist at work, with a triptych, a panel on an easel, and paintings on the wall, dates from the same period as the mummy case with the portrait of Artemidorus.

is easier to appreciate the power of icons than that of relics; but a visit to a church or monastery, or even to the modern Treasury museum in the church of San Marco at Venice, is a reminder of the double importance of relics and icons. One side of this treasury has a superb collection of enamels and chalices and other objects, many of which were taken by the Venetians after 1204 from the Great Palace of the Byzantine emperors at Constantinople. The other side, much less noticed by visitors, holds an enormous collection of relics from various sources. The synergy of relics and icons is also documented by a Byzantine enamel in the British Museum. This is a thirteenth-century gold and enamel pendant reliquary (fig. 40) showing St George on its front, with a prayer in Greek: '[the wearer] prays that you will be his fiery defender in battles.' This pendant has been altered from its original state. When it was first made it must have shown an image of St Demetrios of Thessaloniki, because the inscription around the edge reads 'Anointed with your blood and myrrh'. The object originally must have been planned as a reliquary of St Demetrios, who was famous for the production of myrrh at his shrine. If the pendant is opened, there is space inside for the myrrh and other relics, as well as an embossed supine figure representing the body of Demetrios lying in his tomb in the church. Not

only enamels but also panel icons were made which contained the relics of the saints represented. They therefore offer to the viewer both the symbolic image of the saint and their actual bodily remains. All this shows how the vehemence of opposition to icons at the time of iconoclasm – that they might encourage the belief that the saint was actually contained within the icon – was not an irrational fear. But nevertheless, in the centuries after iconoclasm this argument did not resurface in Byzantium, though it did at the Reformation in the west.

St George is one of the most popular saints to be represented in icons. This is partly because he was, together with Sts Demetrios, Theodore, Prokopios and Merkurios, regarded as one of the major warrior martyr saints, for many the star warrior saint. It is no surprise that the prayer on the British Museum's enamel pendant asks the saint to protect the wearer in battle. St George is also important in his role as patron saint of several countries, such as Georgia, England and Russia. The Museum's collection helps us to see how St George was treated both at the centre of the Byzantine empire, in the case of the enamel made in Constantinople or Thessaloniki, and at the fringes and in Russia. A number of icons in the collection demonstrate how the Byzantine art of Constantinople was accepted and developed in other societies, both Orthodox and Catholic.

The thirteenth-century painting of St George with the Youth from Mytilene has at first sight all the hallmarks of a small Byzantine icon (figs 41–43). The scene, a rare one in Byzantine art, was chosen from a rich repertory, for many tales of the saint's exploits had been told since his (supposed) life and martyrdom at Lydda (Diospolis in Palestina) on a 23 April in the early fourth century. The Life of St George was a well-known text in Byzantium, and further texts record his many posthumous miracles. In this painting St George is mounted on a white horse and rides across a landscape of hills and water. As well as the saint there is a small pillion rider, holding a large glass of red wine. Surrounding the figures and horse is a (now tarnished) silver-coated gesso ornament; this decoration was fashionable in the thirteenth century in Cyprus and the west but its primary function in this case may have been to enhance the panel so that it resembles precious metal. The name of St George was written in red Greek letters on either side of his face, but is in part worn off today. Other areas of the painting too are abraded, including the tip of the saint's spear, and gold leaf on many parts of the figure which must have given him a bright and shimmering aspect. The scene depicted is a youth being rescued by St George. Among that saint's posthumous miracles, the imagery resembles most closely the rescue of a young boy from Saracen captivity on Crete and his safe return to his home and mother on the island of Mytilene, supposed to have taken place in the tenth century. The boy holds the glass of wine he was offering to his captor when rescued by St George on horseback. Though relatively rare in the early Middle Ages, the iconography became more common in later centuries when its meaning is often said to symbolize the rescue of Orthodox Christians from Islamic domination after 1453.

40. Gold and enamel pendant reliquary with Sts George (above) and Demetrios (below)

Thessaloniki, thirteenth century. Diam. 3.75 cm; thickness 1.05 cm
British Museum

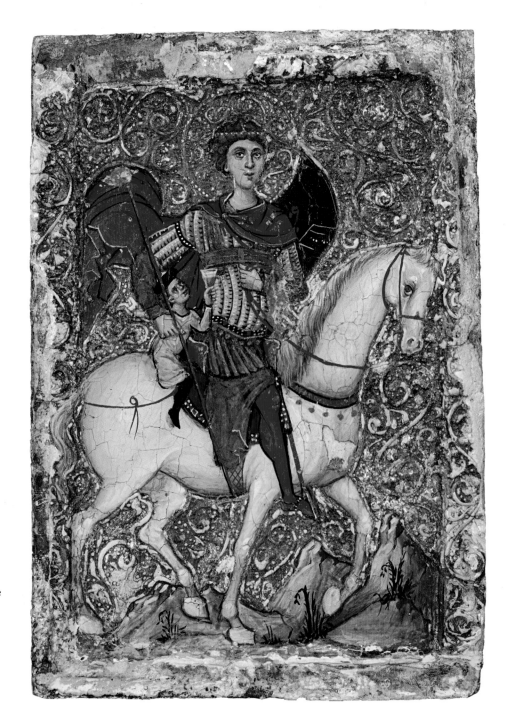

41. Icon with St George and the Youth of Mytilene

French artist working in the Levant, mid-thirteenth century. 26.8 x 18.8 cm British Museum

This painting first appeared at a London auction of icons in 1978 when it was described as a work of little interest: Russian and nineteenth-century. In 1984 I reversed this assessment and described it as a piece of major historical importance, arguing that it was most likely painted in the Holy Land during the Crusades and executed by a western artist. Since then the panel has been the subject of further research and publication, and in 1997 was included in the exhibition *The Glory of Byzantium* at the Metropolitan Museum of Art in New York. Its dating to the middle of the thirteenth century has been accepted in the literature, due to its similarities in style (most obviously the conspicuous rolling eyes of the figures) with a cycle of St Francis in the wall paintings of the Kalenderhane Camii at Istanbul, which dates shortly before 1261, and with the Arsenal Bible (fig. 44), often connected with the visit of St Louis of France to Acre in 1250–54. But the contentious issue is to determine where it was painted and how far

42. Detail of the icon with St George and the Youth of Mytilene (fig. 41)

The head of St George has distinctive rolling eyes, also found in other icons and manuscripts produced at Acre or at Sinai.

43. Detail of the icon with
St George and the Youth
of Mytilene (fig. 41)

liure don rci Salomon fiz
de Dauid rci disrael.

44. Arsenal Bible, folio 37r, King Solomon seated with Divine Wisdom, with a small boy to his right and Christ and the Virgin Mary above

Western artist working for King Louis IX of France at Acre, 1250–54. 28 x 20.2 cm Bibliothèque de l'Arsenal, Paris

we can understand the career of the artist and the function of the icon. The icon has also been attributed to Cyprus for example (as has the Arsenal Bible as the possible commission of a Crusader knight in some palace or castle there). It has been noted that the features which echo western painting, like the curious armour and the 'Gothic' swing of the horseman, might indicate not that it is the work of a western artist, but rather an influence of the west on a local Byzantine artist. In other words, this is certainly a painting with an international character, but it cannot be designated as Frankish, Crusader, Byzantine or even Levantine with any real clarity. It signals the universal popularity in the thirteenth century of St George, and should, it can be argued, be taken as a token of his appeal to all Christians, whether Orthodox, Catholic or a member of one of the eastern, non-Orthodox churches of the Middle East. From this point of view, it both documents the close contacts of the east and the west, and also prompts us to look for differences.

It does seem important to pursue the question of whether this was a conventional Byzantine icon or planned as a western devotional panel. One of its puzzling technical features is that scientific analysis revealed the use of oil as well as tempera in the painting, and in the present state of knowledge this can only be documented as a western practice. But how was it to be used by its owner, and was he Orthodox or from the west? The panel was obviously made for use in the cult of St George, and declares the power of the saint to continue to make miracles after his death. It encourages the viewer to believe that the powers of St George on earth remain alive and well and that, if invoked, he might even appear in person. This is certainly not a simple narrative picture. It is what St John of Damascus called 'a receptacle of divine energy'. Its function might have been as an image blessed at a pilgrimage site and taken away as a souvenir, or as an image designed for dedication as a gift at some holy place. It is also unclear whether its function was to serve a military or civilian owner: it might have been made for a monk as much as for a general. St George was popular with soldiers, but also with the civilian population.

The way forward out of this dilemma is to use traditional art-historical methods of attribution. Since 1984, when the panel was first published, the collection of the monastery of St Catherine's at Sinai has become more accessible to visitors and some of its icons have been displayed in exhibitions in the United Kingdom, Russia, Greece, Italy and the USA. This has allowed us to make close comparisons between the British Museum's St George and some of the panels at Sinai, several of which have also been connected with western artists in the literature. Looking at the thirteenth-century paintings at Sinai, of which there are dozens, we find that they can be grouped in sets which show very similar features. Some of these sets include panels which are signed by individual artists, such as one Petros (who signs with the phrase 'Prayer of Petros, Painter' in Greek). Another icon painter, Stephanos, signed his pair of large icon panels of Moses and Elijah with long inscriptions in both Greek and Arabic. Both of these artists were producing Byzantine icons for use in the monastery, and perhaps were working there. None of the icons in which we can detect western style – and sometimes specifically western iconography inappropriate for a Byzantine viewer – is signed. But distinctive artistic personalities can be suggested on the grounds of related stylistic features and indeed, when Kurt Weitzmann first published these icons in 1966, he did just that, dividing them into groups attributed to individual workshops, ateliers or artists whose 'names' he invented.

The same stylistic features which are characteristic of the British Museum's St George are certainly matched in a number of icons at St Catherine's monastery. One such panel represents St Theodore and St George Diasorites (fig. 45). This epithet for the saint is new in this period and it is not certain what it means (perhaps that he came from Syria). St Theodore wears similar armour to St George in the Museum panel, but St George wears a red mantle over his armour. Both figures have the feature of 'rolling eyes', and the frisky white horse is very similar in its details to that in the Museum St George. Greek is used for the inscriptions and, like the Museum panel, the artist is well informed about the iconography of St George. Indeed one is inclined to say that the artist is interested in the more esoteric aspects of the saint's life, and the idea that this information was

45. Icon with St Theodore and St George Diasorites on horseback

French artist working in the Levant, c. 1250s.
23.8 x 16.1 cm
Collection of the Holy Monastery of St Catherine, Sinai, Egypt

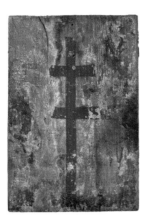

46 (far left). Back of the icon with St George and the Youth of Mytilene (fig. 41)

47 (left). Back of the icon with St Theodore and St George Diasorites on horseback (fig. 45)

The backs of both these icons are decorated with the same motive of a red two-armed cross with the monograms of Jesus Christos.

learned from a visit to the cult pilgrimage site of the saint at Lydda in the Holy Land is not out of the question. A further reason for attributing these two panels to the same artist is the treatment of their backs: both panels are handled in the same way and decorated with a cross that is near identical (figs 46 and 47).

A second related panel at Sinai has an entirely different iconography but the same features of style, including the rolling eyes and the silvered gesso decoration foil against which the four figures are set. This is an icon of the Virgin and saints (fig. 48). Each figure in this icon has been chosen to reflect particular features of the holy pilgrimage site of the Sinai monastery itself, and such knowledge of that environment is revealing for building up a picture of the artist. The standing Virgin holding the Christ child, who is suspended rather than sitting, appears in several paintings at Sinai, sometimes with a representation of the Burning Bush: the type is now known as the Virgin of the Burning Bush, invoking the site around which the church was built in the sixth century and which remained one of its key relics. By the Middle Ages the Burning Bush, which had contained the divinity, was seen as symbolic of the Virgin and the incarnation of Christ. So this is a *locus sanctus* image. Moses is on the left, shown with a short beard as in a number of icons attributed to western artists. Elijah, on the right, is chosen because of the story that he was fed by a raven at Sinai; pilgrims called at a special Elijah chapel halfway up the Moses Mountain before visiting the sixth-century church on the summit where Moses received the Law. St Nicholas, on the far right of the painting, also had a special chapel and cult at Sinai.

If this is a work by the same artist, it adds breadth to our understanding of his working methods. Again the inscriptions are in Greek, and the artist is clearly familiar with the special cults of Sinai. A few more works at Sinai can also be attributed to his hand. One is a small devotional panel of the Virgin and Child in the popular Byzantine Hodegetria type, but in this case with the child on her right arm (fig. 49). The back-

ground is in decorative gesso and here we have evidence that the raised framing is built up in the same way as the frame of the Museum St George. The feature which this panel has in common with the Museum St George is a fictive 'engaged frame'. A proper engaged frame is one that is carved out of the same piece of wood as the icon. But in several cases the icon painters of Sinai have hastily cut corners by adding strips of wood and covering them with linen and the preparation layers so that they appear to be engaged. It seems that in these two panels strips of parchment or paper were folded and attached (like strips of wood) to the edges and were then covered at the same time as the panel with the preparation layers before the gesso and silver leaf was applied. This is an odd technique and links the two icons by a peculiarity of working as well as by style.

Another icon which connects with this artist through the use of rolling eyes is a Crucifixion with saints. The saints on the wide frame around the dramatic Crucifixion scene seem to have been carefully chosen and to have connections with Sinai. The Deesis

48. Icon with the Virgin of the Burning Bush between Moses, Elijah and St Nicholas

French artist working in the Levant, thirteenth century. 32.3 x 25.7 cm Collection of the Holy Monastery of St Catherine, Sinai, Egypt

The background is decorated with silver leaf over gesso, like the icon with St George and the Youth of Mytilene; likewise the engaged frame is made up with strips of parchment and gesso.

49. Icon with the Virgin Hodegetria and Child

French artist working in the Levant, thirteenth century.
24.8 x 17.8 cm
Collection of the Holy Monastery of St Catherine, Sinai, Egypt

The background is decorated with silver leaf over gesso and the engaged frame is made up with strips of parchment and gesso, like the icon with St George and the Youth of Mytilene.

at the top, with Mary and the Baptist on each side of Christ, is flanked by Moses and Elijah. Below them are Peter and Paul on opposite sides; George and Theodore; John Chrysostom and Basil; Catherine and Eirene; Paul of Thebes, Simeon Stylites and Onoufrios. In the bottom corners are Maximos the Confessor and St Dometios. A number of these saints had a special cult at Sinai. St Catherine, whose relics were found at the mountain near the monastery in the Middle Ages and to whom the monastery was dedicated when her relics were brought into the church, has obvious links to Sinai. So does St Simeon Stylites, who had a special chapel in the basilica, and Onoufrios, who had lived in a cave nearby.

One last icon at Sinai needs to be considered as a work by the artist of the British Museum's St George panel. This is a small portable triptych which is the combined product of several painters (fig. 50). When closed, this triptych shows on the left St Nicholas, who is wearing western ecclesiastical garments but gives a Byzantine form of blessing. On the right St John the Baptist looks Byzantine in type, but holds an Agnus Dei medallion, which is a western feature. The painter of these two saints has been identified as Italian in origin. The same place of training (perhaps Tuscany) has been proposed for the artist of the central panel inside the triptych, the Virgin and Child enthroned with archangels. The four scenes on the inside of the wings are, however, in a different style and must be by another artist. They have many features of style which match the Museum St George. Each scene is set against a familiar gesso decorated background and several of the figures have the hallmark attribute of the rolling eyes. The scenes are the Coronation of the Virgin and the Koimesis of the Virgin on the left, and the Finding of Jesus in the Temple and the Lamentation on the right.

If these paintings are all accepted as by the artist of the Museum St George, then we have a set of six different pieces by one artist to consider together. Of course this is not a scientific result, and it is bound to be a controversial one. This is because attribution, the designation of works of art as being the distinctive work of one individual, is not a scientific method but is in part intuitive. Acceptance of such proposals is always provisional in case new evidence turns up. It is also controversial to attribute sets of paintings from the Middle Ages to individuals rather than, as is often done, to the more inclusive notion of 'workshop'. But there is a case for speaking of individuals as, in this period, there is little evidence to support the idea that icon painters were any more than just that: they were professional artists with very few helpers, and sometimes they were priests or monks who also painted.

The value of identifying several works by the painter of the British Museum's St George is that it should be possible to build up a more rounded picture of his career. Of course his personality remains a blank and it is only a statistical probability to assume that the artist was male. The western echoes in his style and the connection with the Arsenal Bible, a product of French manuscript painters and scribes, hint that he might have been first trained in France (in the thirteenth century that most likely means Paris), but his use of Greek and knowledge of Byzantine iconography makes it certain that he travelled to the east. He seems to have been at some time in the coastal city of Acre, which was the capital of the Latin Kingdom in the thirteenth century after the loss of Jerusalem in 1191 and remained so until its fall in 1291. The possible French connection can be confirmed through clues in the other panels of this group of six. For example some of the details of the Crucifixion iconography in the Sinai panel resonate with the same scene

50. Triptych with Virgin and Child enthroned, with the Triumph and Dormition of the Virgin (left) and the Finding of Jesus in the Temple and the Lamentation (right)

Centre: Italian artist working in the Levant; wings: French artist working in the Levant, thirteenth century. 56.8 x 47.7 cm (central panel), 53.7 x 21.7 cm (left), 53.8 x 21 cm (right). Collection of the Holy Monastery of St Catherine, Sinai, Egypt

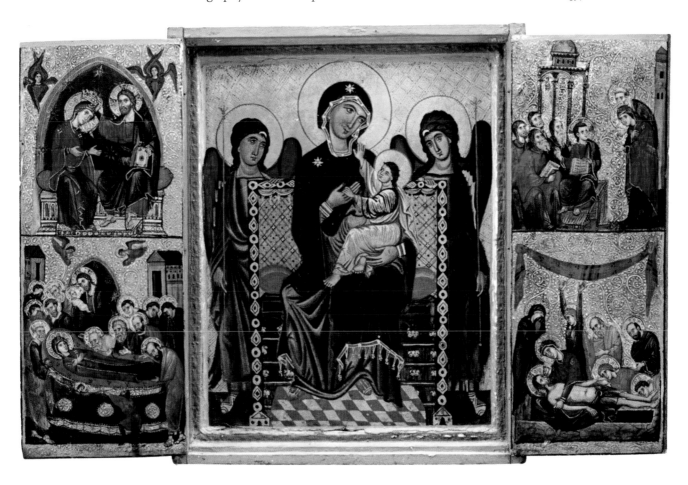

in a manuscript produced in Acre, known as the Perugia Missal (it now belongs to the collection of the Cathedral of Perugia). This is actually the only manuscript attributed to Acre which has a firm connection with the city: it contains a sentence in its calendar referring to the dedication of a church at Akko (*Dedicatio ecclesie Acconensis*). The two Crucifixions have some revealing details and gestures in common: the Virgin touching the corner of her mouth with her thumb, St John touching his nose with his little finger, and intense weeping angels. The hands and feet of Christ are fixed to the cross by just three nails: the Byzantine convention was to use four and the new iconography was a western idea. The scribe of the manuscript uses French forms and initials. Yet the full modelling of the figures and the low wall behind the figures shows a knowledge of Byzantine art, and suggests that the artist of the Crucifixion miniature was working in the east, and very likely at Acre in a French environment.

Even more revealing are the wings of the Sinai triptych. In these four scenes it would be very difficult to make the case that these are by a Byzantine artist or indeed intended for Orthodox use. The Coronation of the Virgin is a western theme which is not accepted in the art of the Orthodox church at this time, and the specific iconography of the Finding of Jesus in the Temple is a scheme paralleled in western manuscripts such as the Bibles Moralisées. The Koimesis, however, owes much to Byzantine models, both for the architectural composition and the details of the figures. The Lamentation looks quite close to Byzantine models at first sight, but there are some western elements, such as the way in which the body of Christ is suspended over the open tomb rather than laid on a slab, and also in the high exaggeration of the poses and gestures of the mourning women.

Put together these features point to the artist of the British Museum's St George panel as being a westerner from his ingrained habits of production, most likely French. Yet it is still difficult to establish his actual career. The panels at Sinai have been the subject of considerable art-historical debate. Were they painted by itinerant artists at the monastery where they are now situated? Were they painted at Acre – or even Cyprus – and at some time transported to the monastery? These are the main suggestions found in the literature. And these questions are about production rather than about the patrons for whom they were made. Were they intended for pilgrims at Acre or Sinai who wanted portable images? Or perhaps for the churches or private homes of Crusaders? Were they even intended to appeal as art to Orthodox Christians?

It may be that these questions are just too simple and the historical circumstances much more messy. Certainly if one risks fitting together this small amount of evidence about the artist of the St George into a narrative, it becomes suspiciously tidy. An added complication is that we might be dealing with a second-generation artist, who was born in the east but trained by a western father. But it is worth considering the following scenario. If the artist started his career in Paris but for some reason decided to travel east,

we might envisage him accompanying the armies of the Seventh Crusade of 1248–54, led by King Louis IX of France, who set out from Paris in 1248 and spent the winter on Cyprus. In 1259 the armies went to Damietta on the Nile. After various disasters in Egypt, Louis was only able to reach Acre in the summer of 1250. He remained there until his money ran out in 1254, when he returned to France. But the artist of the St George could have spent time in Cyprus after his arrival in 1248. The icon industry there was flourishing and, after some time familiarizing himself with the work of the local artists, he could have moved onto Acre by boat. If we are to argue that all our panels were produced at Acre, then he might have set up a studio and remained there for years; alternatively he might have returned home to Paris. But another scenario is that he travelled in the Holy Land, visited the pilgrimage site of Lydda, and perhaps worked there. Subsequently he could have moved on to the monastery of St Catherine's itself, and in that famous and popular destination of pilgrims, he perhaps learned to include in his panels some of the special references to local interests and saints. It is possible to see him as a travelling artist who seems to have learned Greek and knew quite esoteric aspects of the Christian saints. He was highly sensitive to Byzantine art and worked in its forms, but revealed his western antecedents when it came to creating narrative scenes on his icons.

The historical dilemma presented by the existence not only of this homogeneous set of panels but dozens of other pieces is: why are they now in the collection at Sinai? Were they made for use or sale as souvenirs at the monastery, or have they arrived there piecemeal over the years (certainly true of several manuscripts in the library)?

There is a still broader issue raised by the portrait icon of St George. In view of the numbers of these panels which were produced in the Middle Ages, we must wonder how icons were acquired by their owners. The evidence considered in chapter two suggested that icons were not necessarily expensive items: they could be acquired at differing levels of cost. But what happened in the Crusader Kingdom city of Acre, inhabited by both westerners and easterners? It was a busy trading centre as well as a transit point for pilgrims. We have an evocative document from Acre, written by the executors of the will of the Count of Nevers, Eude of Burgundy, who had come from the west to the city and died there on 6 July 1266. It details his household accounts and possessions and shows that in his house were manuscripts, some brought from France, and the furnishings, including paintings, of two chapels he had created. How did such citizens acquire their possessions? It seems likely that artists set up studios which acted also as shops, perhaps similar to the ancient artist's workshop represented in the sarcophagus from Kerch (see fig. 39), which seems to show samples of his work for sale on the wall. David Jacoby, in a historical study of Acre, believes that art was definitely sold through shops. He suggests three patterns of commerce. The first involves patrons personally commissioning individual works which would, as a consequence, be painted according to their wishes. This is the most expensive pattern. The second proposes that some people bought icons

51. Icon with St George slaying the dragon (known as the 'Black George')

Russia (?Northern Novgorod province), late fourteenth century. 77.4 x 57.4 cm British Museum

displayed by the artist, but had some distinctive individual features added before purchase, such as an inscription or even their own portrait to personalize the devotional power of the panel. But probably the third pattern was the commonest: that most consumers bought a ready-made icon. To catch the eye of his viewers the artist might have inserted motives which would appeal to a multicultural target audience, such as Greek or Latin inscriptions and western or eastern iconographies. One can, of course, envisage such a studio–shop either at Acre or at pilgrimage sites or frequently visited monasteries.

In many ways the British Museum's St George panel can illuminate the nature of Byzantine portrait icons, despite its particular circumstances as the work of an artist travelling to the east during the Crusades. But it was not only westerners who roamed the medieval world in search of work. Byzantine artists themselves were remarkably mobile, working both at western centres, such as Venice, Sicily and elsewhere in Italy, and at places in the east of the empire, such as Georgia and the Holy Land. Another area which attracted Byzantine artists was the Russian lands, and the history of early Russian art after the paraded conversion to Christian Orthodoxy in 988 is one of interaction between itinerant Byzantine and local Russian painters and architects. The British Museum's collection includes nine representations of St George in icons from several centuries, but the one which conspicuously contrasts with the thirteenth-century St George is from Russia and has been dated to the late fourteenth century, the so-called 'Black George' (fig. 51). This is a much larger and more monumental panel than the thirteenth-century icon, and one can instantly suppose that it had a different function, possibly intended to be permanently on display in a church dedicated to St George. The subject of this icon, the slaying of the dragon, is a familiar one in the cycle of the miracles of the saint. After iconoclasm St George appears in Byzantine art on horseback killing a dragon or serpent, the personification of evil, and after a few centuries he is seldom represented without this attribute. Unlike a later Russian icon of St George in the British Museum's collection (fig. 52), a princess is not included. She is in fact a relatively late addition to the saint's iconography; it seems that the story of his rescue of a princess from the jaws of a dragon originated in Georgia in the eleventh century and soon spread. A striking early example is found in North Russia in the church of St George at Staraya Ladoga around 1167. The story of the princess was believed to have happened while the saint was still alive: it is not told as a posthumous miracle, like the story of the youth of Mytilene who is rescued by the saint centuries after his death. It is seen as a historical event of around 300 which induced a whole city to convert and be baptized as Christians.

The 'Black George' represents only the saint and the animal he lances, and the icon is distinctive for the black colour of the horse. The files of the British Museum contain a fascinating account both of the chance discovery of the icon in Russia and the circumstances of its purchase. The panel was first seen in a small village in the district of Ilinsky on the river Peniga in North Russia, acting as a window shutter in a barn. All that was

**52. Icon with St George
and the dragon**

Russia, eighteenth
century. 40.4 x 35 cm
British Museum

visible was a painting of the eighteenth century, but there seemed to be more layers
beneath. An initial cleaning uncovered a painting dating from the seventeenth century
and below that an earlier layer. At this point it was sent to Moscow for professional clean-
ing, and this revealed the present image of St George and the dragon, which was immediately
dated to the end of the fourteenth century and attributed to an artist from Pskov (in the
area of Novgorod). The dating depended on the nature of the technique and the wood,
a thin piece of lime (two pieces fixed together) on which cloth and gesso was applied.
It is the relative thinness of the wood which helps to date the panel and to indicate that
it is not from the eighteenth or nineteenth century. Some gold leaf was used in the icon
(in the halo, at the point of the lance and on the armour) and the palette is typical of
the period of the fourteenth century. The icon was found by Maria Rozanova, wife of
the prominent dissident author Andrei Siniavsky. The couple were allowed to leave the

Soviet Union in 1973 and to take their possessions with them to the west. The icon was purchased by the British Museum in 1986.

The obvious difference between the thirteenth-century western treatment of the St George and this panel which fits into Russian taste of the fourteenth century is that the earlier icon is minutely detailed and takes great care to make the horse and the two riders relatively lifelike. The Russian painting is equally delicate in detail, but the clear lines and silhouette appearance of the figures appeal to a different aesthetic, one that is very modern in its attractions. It was just this kind of icon that stimulated Matisse and his subsequent work when he visited Russia in 1911, and wrote of icons:

> They are really great art. I am in love with their moving simplicity which, to me, is closer and dearer than Fra Angelico. In these icons the soul of the artist who painted them opens out like a mystical flower. And from them we ought to learn how to understand art.

86

Icons after Byzantium

In 1909 O.M. Dalton, the well-known curator of Byzantine art at the British Museum and author of the major reference handbook of the early twentieth century *Byzantine Art and Archaeology* (1911), published in *The Burlington Magazine* a study of the icon with four church feasts (see fig. 30). In this article he gave the rather damning assessment of Orthodox icons after 1453 as being '*œuvres de piété* [works of piety] rather than works of art'. This was probably a common attitude towards the icon a hundred years ago, and the same sentiments are likely to be widespread enough today, if differently expressed. The icon is a problematic medium for art historians, particularly if they have been trained to look at art in the way that Giorgio Vasari's *Lives of the Most Excellent Italian Architects, Painters and Sculptors* so persuasively set out in 1550 and 1568. The hero of this sixteenth-century account of the history of art is Michelangelo, whose work is seen as the climax of an organic evolution of post-antique art, effectively realizing the aims of naturalism and realism. In comparison with the scholarly study of both the progressive art and complex personality of Michelangelo, the world of the icon can all too easily come to be regarded as stereotyped, conventional and lacking any manner of genius. Partly under the influence of Edward Gibbon's *Decline and Fall of the Roman Empire* (1776–88), which condemned the Byzantine period for its 'triumph of barbarism and religion', the study of Byzantium and the Orthodox world, including the Russian lands, has long been regarded as marginal rather than integral to art history.

It has become more and more difficult to maintain such disparaging views. The role of the icon as a greatly effective medium in communicating religious ideas and

53. Icon with St Jerome

Cretan, fifteenth century.
34.5 x 27 cm
British Museum

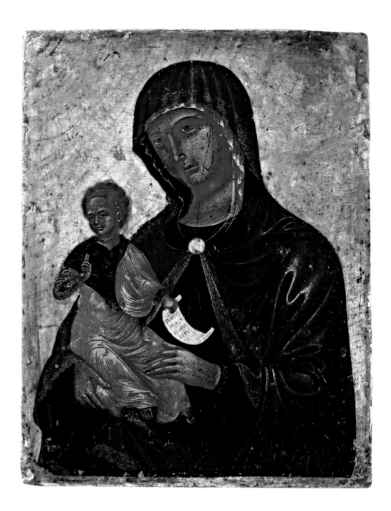

54. Icon with the Madonna della Consolazione

Cretan, seventeenth century. 35 x 27.5 cm
British Museum

spiritual emotions is now recognized in many studies. With the rise of art history as the study of world – not just western – art, it is no longer possible to see the Orthodox world as marginal: that was only true from a narrow perspective and definition of western art. The icon has finally entered the Academy. But this does not mean that art dating from after the fall of Constantinople in 1453, so-called 'Post-Byzantine' art, has instantly become a familiar part of the discourses of art history. There is still the problem of how to approach a living religious art, for both believers and non-believers. It is also true that the imperial and social structures of the Byzantine empire within which the icon industry flourished came to an abrupt end in 1453. The imperial court disappeared, although the Orthodox Patriarch of Constantinople, the head of the Byzantine church,

remained in the city, and still resides there today. Since the majority of icons in the British Museum's collection date from after 1453, they are part of that historical problem. The aim of this chapter is to ask some questions about ways of viewing such icons.

As long as Constantinople was the capital of an extensive Mediterranean empire, it was the art of that city and its dependent regions that defined Byzantine art in the eyes of art historians. But even this was an arbitrary definition, as icons were made over a wide geographical area, and served groups which saw themselves as part of the Orthodox communion, such as Georgia and parts of Syria, as well as those who belonged to non-Orthodox groups, such as Armenia and Coptic Egypt. Outlying churches, such as those of Nubia and Ethiopia, were also strongly attached to the use of icons (Ethiopia

55. Icon with the Noli me Tangere (Touch me not)

Cretan, seventeenth century. 63 x 47 cm
British Museum

has more icons attributed to the hand of St Luke than any other country). It is also not simple to distinguish Orthodoxy and the use of icons from western 'Catholic' practices in the Middle Ages: the early painted panels which decorated the churches of Rome were often painted by Italian artists, but they functioned in the church in ways which overlapped with Orthodox practices (particularly how they were carried in procession between the churches of the city). It has already been suggested that there was a continual tension between the eastern and western churches in the Middle Ages, and this seems to have resulted in a creative and mutually advantageous situation.

At the heart of these questions about the icon and its qualities as an art form, and Dalton's adverse assessment of the value of later icons, is hidden a problematic conceptual debate about 'purity'. It involves an essentialist assumption about the existence of the 'pure' Byzantine icon; later or regional divergences in the appearance and functions of icons are regarded as being in some way inferior to this standard. Only by reworking this approach can we hope to advance and to remove the stigma of decline and difference. The 'purist' stance has already been implicitly criticized in the discussion of the British Museum's St George panel (see fig. 41), which was accepted as having all the features of a Byzantine icon, but happens to be the work of an artist trained in the techniques and styles of the west. There is really no reason to deny it the description of an 'icon'. It is as 'Byzantine' as the icon of the Heavenly Ladder of St John Climakos (see fig. 11) when one considers how it might have functioned. The art of Constantinople is also full of variation, and no one work is more Byzantine than another. The same is true of the 'Black George' (see fig. 51). It was painted in Russia in a style which owes much to Byzantium, but we know of no Byzantine icon which exactly resembles it.

This chapter will look at those icons in the British Museum's collection which come from the former regions of Byzantium (but outside the Byzantine empire) and at those from Russia, and explore their character. This needs a short historical sketch for orientation. After the occupation of Constantinople in 1204 by the Crusaders, the Byzantine empire was split up into a number of Latin Kingdoms. Some of these remained in western hands after the return of the Byzantine emperor Michael VIII to Constantinople in 1261. Several of the islands in the Aegean and Ionian seas were never recovered by Byzantium, nor was Cyprus, which was lost in 1191 when it was taken over by Crusaders. The most important island for the continuing, and indeed expanding, production of icons was Crete, a Venetian possession from 1210 until 1669, when it was captured by the Turks. The Venetians exploited Crete for its agricultural products – grain, wine, olive oil, cheese and wood – and as a useful base for Mediterranean trade, and their presence can be seen from extensive western-style buildings in the three main cities of Candia (now Heraklion), Rethymno and Chania. They built Gothic churches, redeveloped the harbours and beautified the streets with elegant fountains. The indigenous Cretan population was, however, controlled in various ways, and most notably the Orthodox church

was not allowed to have any higher clergy on the island. The priests were limited to 130 and they were under the jurisdiction of the Latin archbishop of Crete. Yet the island was extremely prosperous as part of the Venetian Republic, and this is reflected especially in the enormous quantity of art produced in this period, both in the wall paintings of its many churches and in the production of icons. What is special about Cretan icon painters is that they innovated in several ways. Some icons remained close to earlier Byzantine traditions; for example there was the continued production of versions of the Virgin Hodegetria, clearly based on the model in Constantinople (or copies of it). Other icons are very different, and have been altered under the influence of the west, particularly Italian Renaissance art. The Venetians not only brought works of art with them, but clearly also purchased icons from Cretan painters. Some of these icons had inscriptions in Latin to fit their clientele, others subtly combined the iconography with styles of western religious paintings (such as the seventeenth-century icons with the Madonna della Consolazione, fig. 54, and the Noli me Tangere, fig. 55). They sometimes have an element of sentimentality. The hybrid approach and merging of eastern and western art seen in the British Museum's St George is taken a stage further, but this time by Orthodox artists.

The historical documentation of this Cretan art is quite different from that of Constantinople, where most records have disappeared. The notarial archives of Venice still contain many documents from Venetian Crete, such as wills. These were transported by sea to Venice from Candia in 1669, and many have been recently published. Also Cretan painters often signed their icons. Putting this information together we learn a great deal about the careers of a number of artists, and much research has been devoted to the major figures, such as Angelos Akotantos (active 1430s–1450s), Theophanes the Cretan (c. 1500–59), Michael Damaskinos (1530/5–92) and Domenikos Theotokopoulos (better known as El Greco; b. Candia 1541, d. Toledo 1614). All these artists worked both on Crete and elsewhere (the last two including in

56. Icon with the Virgin of Vladimir

Byzantine (Constantinople), c. 1131 and later restorations.
78 × 55 cm
State Tretyakov Gallery, Moscow

57. Icon with St George slaying the dragon

Russian (Novgorod), early sixteenth century. 65 x 49.4 cm
British Museum

Venice itself). We also have records of a number of families who were painters through several generations, notably the Ritzos and Tzanes families. Angelos was extremely prolific as a painter; based at Candia, he worked in both a Byzantine and a hybrid style, showing his knowledge and interest in western art, and he perhaps was a proponent for the Union of Churches discussed at the Council of Florence in 1439. The consequence of this historical situation is that recurrent patterns of iconography and style are to be seen in the icons of Crete, so much so that many art historians have spoken of Cretan art as a distinctive creation.

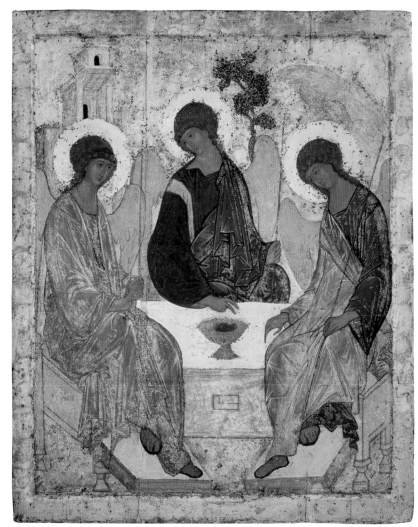

58. Icon with the Trinity, by Andrei Rublev

Russian,
c. 1410–20.
142 x 114 cm
Tretyakov State
Gallery, Moscow

Crete's multicultural situation and composite art were due to the presence of its Venetian rulers. Everything changed after 1669, when the occupying power was Turkish, based in Istanbul. However, icon painting did continue in the Orthodox community on Crete, and there are today monasteries and convents on the island where the sale of icons painted by monks and nuns is part of the modern economy. The other place where huge numbers of icons were produced was in the Russian lands. Despite a quite different historical situation, the same issues of how to come to terms with the art of the Italian Renaissance and the Catholic west were clearly a challenge there too.

After the conversion of Kiev to Orthodox Christianity in 988, Ukrainian and Russian churches were decorated by Byzantine artists. Russian artists operated at first in their shadow, but soon were able to work very successfully along the same lines. The most famous imported icon from Constantinople was the Virgin of Vladimir (fig. 56), which came to Kiev in the twelfth century, was moved to Vladimir and then to Moscow. On this icon Jesus has his arms around the neck of the Virgin and is kissed by her. It is one of the most emotional of all Byzantine icons. The icon was said to have saved Moscow from Tamerlane in 1395 and from the Poles in 1612. As a miracle-making icon, it was much copied in Russia, and there are many versions still in existence. The British Museum's collection includes five copies, dating from the seventeenth to the nineteenth centuries. The history of the icon in the period before 1453 shows close links between Constantinople and the various cities of Russia, such as Kiev, Vladimir, Novgorod and above all Moscow as it gradually became the dominant centre, especially from the defeat of the Mongols in 1480 and the reign of Ivan III. An artist recorded in the writings of the period is Theofan Grec, who migrated from Constantinople and went to live and work in Russia, at Novgorod in 1378 and later in Moscow (he is documented there in 1405). His surviving wall paintings and icons show him to be one of the major Byzantine artists of the period, and he is said to have worked with great speed and fluency without needing models to copy from. He worked with a number of Russian artists, including Andrei Rublev, who shows his influence. After Theofan Grec, we know of no high-profile Constantinopolitan artists who went to Russia.

The traditional way to look at Russian icons is either to trace the character of individual icon painters, mostly from Moscow, and associate their style with 'schools', or else to treat the major cities of the Russian lands as geographic centres whose works can be classified. As a consequence, most early fifteenth-century Russian icon painting is attributed to Rublev and his school, and most of that of the late fifteenth and early sixteenth centuries is attributed to another documented personality, Dionisy, and his school. The next cluster is the so-called Stroganov School, though this actually refers to a group of artists from Moscow working under the patronage of the rich Stroganov family of merchants in the late sixteenth and seventeenth centuries. Although these attributions are in many ways attractive – there often seem to be distinctive features, such as a preference for certain colours, common to each of these so-called schools – they probably give a distorted view of the nature of icon production in Russia and the actual numbers of icon painters. Rublev is credited with an incredibly high number of works, virtually none of which is documented, and the existence of other artists is ignored.

The alternative scenario in terms of geographical schools may be equally distorting, although we do know a great deal about the material history of these Russian cities from archaeology, particularly in the spectacular evidence from the medieval layers of Novgorod, which includes birch-bark letters with over nine hundred inscriptions.

59. Icon with St John the Baptist

Cretan, sixteenth century.
89 x 64 cm
British Museum

60. Icon with Sts Cosmas and Damian

Cretan, seventeenth century. 67.5 x 55 cm
British Museum

Again one can see good reasons for grouping icons in clusters and it may be that some of these stylistic similarities are due to familiar practices in the cities of Novgorod, Pskov, Yaroslavl, Tver and Moscow. One striking icon in the British Museum's collection has on this basis been attributed to Novgorod in the fourteenth century (fig. 57). But explaining the development of icons in Russia simply along the lines of schools of artists or cities underplays questions of functions and historical developments. It is the method used by nineteenth- and early twentieth-century art historians for the treatment of Italian Renaissance art, and it places all the emphasis on the producers of works of art rather than on the viewers and their needs. This may not be the most productive way to handle the icon. It is true that up to the twelfth century most icons are unsigned, and so anonymous productions. By the fourteenth century in Crete, it becomes relatively common to sign icons, and we know the names of dozens of Cretan painters. But this information seems less important for understanding the history of the icon than to examine the ways in which the finished products served society for generations after their production.

A particularly important factor in the long history of the icon is the issue of State and ecclesiastical control over icon production. Here the fact of Byzantine iconoclasm in the eighth and ninth centuries is crucial. The ban on figurative images was imposed from on high by the Byzantine emperor and the church was obliged to follow his lead. The State was in control of imagery allowable in the church and the home. When the first period of iconoclasm ended during the reign of the Empress Eirene, the Seventh Ecumenical Council of Nicaea in 787 attempted to bring the control of art back into the hands of the church: icons, they said, were a tradition of the church and the painters supplied the workmanship. In Moscow after 1453 the Russian Orthodox church made a number of attempts to regulate the clergy and the practice of art. The Council of a Hundred Chapters (Stoglav) of 1551 discussed the icon of the Holy Trinity, since at that time icons of the 'Paternity' and the 'New Testament Trinity' had become widespread. The problem was how God the Father could be represented in icons; the decision was made that the Byzantine solution adopted by Andrei Rublev in his large painting of the Trinity for the Trinity Sergios monastery in the early fifteenth century – showing the Trinity in the form of three angels (fig. 58) – was the model to be followed. One of the aims of the council was to regulate iconography and style on the understanding that an icon reveals rather than depicts Christian truths. By the seventeenth century in Russia the institution of the church was even more ambitious. The monk Nikon (1605–81) was elected Patriarch of Moscow in 1652, and reformed many liturgical practices, bringing the Russian service books back into line with the Byzantine practices of Constantinople. He prescribed (on pain of excommunication) that Russians should stop making the sign of the cross with two fingers, but instead, like the Greek Orthodox church, should use three. In fact his reforms of Russian practices proved too conservative for some, and were

61. Triptych with the Koimesis (Dormition of the Virgin) in the centre, flanked by St George, St John Chrysostom and St John Prodomos (left-hand panel), and St Demetrios, St John the Theologian and St Basil (right-hand panel)

Greek (?Mount Athos), late sixteenth century. 17.5 x 13 cm (central panel); 13.8 x 6.4 cm (left-hand panel); 14 x 6.5 cm (right-hand panel); 26 cm wide when open
British Museum

seen by the tsar as an attempt to break loose from State control, so Nikon lost his position. Although the bishops upheld Nikon's reforms, many of the priests and the laity did not, and they formed a splinter group, now described as 'Old Believers'. Many icons from the seventeenth century onwards were made for the Old Believers, who refused to accept icons made in a realistic style. The problems of icon traditions were further emphasized with the decision of Peter the Great (1672–1725) to move his court to St Petersburg and to downgrade the position of the Patriarch of Moscow. His programme of modernization exacerbated the debates in the church on the importance of the Byzantine tradition in art over western artistic ideas; Peter favoured the 'life painting' of foreign artists over native Russian icon painting. In Russia, as in Crete, artists were aware of western stylistic practices, and in various ways incorporated them into their work. It was patrons who decided which kind of icon they preferred, and the attitudes of those patrons ranged from the deeply conservative to the progressive in their tastes.

One aspect of icon production which has been thought to result from the Stoglav decisions is the encouragement of tracings and cartoons, and the use of painter's guides. There is good evidence of such aids to work, particularly from the eighteenth century onwards, but it is important to distinguish between common studio practice and the idea that the church was imposing iconographical and stylistic rules through the circulation of books. The best-known painter's guide, the *Hermeneia* of Dionysios of Fourna, was certainly the work of a priest–painter, yet it was in no way an official church document, but rather a set of recommendations based on his experience and knowledge. The existence of pricked drawings used by icon painters in this period (the largest collection is in the Benaki Museum, Athens) is certainly evidence of how icons could be copied and reproduced, but attests to the developing mass production of icons rather than the following of church prescriptions. The British Library has a booklet from the middle of the eighteenth century with jottings and drawings by an artist who worked

62. Icon with the Koimesis (Dormition of the Virgin)

Greek, seventeenth century.
44.5 x 70.7 cm
British Museum

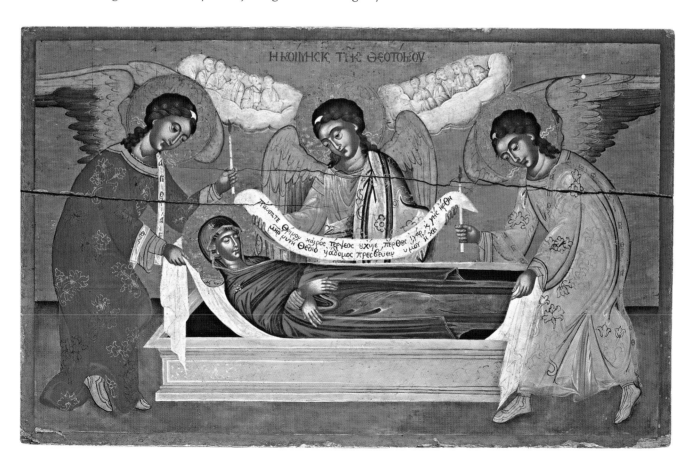

in North Greece. It has scenes from the lives of the Virgin, Christ and saints, and decorative motifs, along with technical remarks about painting, recipes for medicines, passages from the Old and New Testaments, and records of local events. Theofan Grec on the other hand, as has already been noted, was an artist who did not need to work from models.

Notable in Russia and Greece is the development of the mass-produced icon, in part led by the growing popularity of printed 'paper icons'. But it was also encouraged by the important technique and fashion of the revetment of icons. The idea of covering the background of icons with precious-metal sheets originated in Constantinople, perhaps in the Komnenian period. The interest in this practice can be seen in the British Museum's St George (see fig. 41), where the silvered gesso may be an alternative way of enhancing the figure of the saint by enveloping the figure in a rich design. In Russia the development of revetment (*oklad*) is a dominant aspect of the icon. A hand-stamped sheet of silver or silver-gilt (the *basma*) could be built up into an oklad which covered the icon, revealing only the painted face, hands and feet of the saints. By the seventeenth century the oklad was often just one sheet of metal repoussé. This meant that minimal painting could be carried out on the panel beneath, and so the quality of work might decline. Before the seventeenth century the icon was normally fully painted and the background would have been in gold. However, from the sixteenth century in Russia, icon painters used thin sheets of silver with small amounts of gold beaten in. They also sometimes followed the old Byzantine trick (found in the icons at St Catherine's at Sinai) of using silver leaf and covering it with a reddish shellac, which gave a good semblance of gold. The problem with looking at Russian icons today is that the oklad has often been removed during restoration (nail holes give evidence of their previous fixing), and in the cleaning process the background gold, whether fictive or very thin, has been lost, giving the incorrect impression that Russian icon painters preferred plain white backgrounds.

CRETAN ICONS

The British Museum's collection includes some major Cretan icons, which soon reveal their intricacy as art. An example is the panel of St Jerome in a landscape (fig. 53). Once owned by John Ruskin, who gave it to William Ward, it was later purchased by Alfred A. de Pass and exhibited in 1905 in London. In 1920 De Pass gave the panel to the National Gallery, where in 1951 it was catalogued by Martin Davies and allocated to the early Italian schools volume. It came to the British Museum in 1994. St Jerome, dressed as a cardinal, extracts a thorn from the lion's paw with his quill pen as a tool. He sits on a large solid throne of a form known in many Tuscan early Renaissance paintings, which somewhat belies his ascetic life in the desert of the Holy Land in the fourth century. In the background are a church and two rocky hills. The saint turns away from his writing, and the open book contains one of his own texts in Latin, the moral recommendation:

63. Icon with twenty-five scenes from the Akathistos Hymn

Greek Islands, late seventeenth–eighteenth century. 57.8 x 39 cm (including frame)
British Museum

64. Upper part of a Royal Door with the Annunciation to the Virgin

Northern Russian, early seventeenth century.
58.5 x 87 cm
British Museum

'Overcome anger through patience; rejoice in the knowledge of the scriptures, and you will disdain the sins of the flesh.' The National Gallery catalogue dated the panel, apparently painted on cypress wood, to the fourteenth century and attributed it to the Venetian School, noting the assessment of some scholars that it was a work which combined Venetian and Byzantine elements. Others had already dated it later than this. The icon was republished when it was included in the British Museum's *Byzantium* exhibition of 1994; the new research changed its date and context. The form of the rocky landscape and the three-aisled basilica is found frequently in Cretan art, thus it was attributed to Crete as an icon of the early fifteenth century. While the Cretan connection now seems certain, the precise date is still open to question, and another suggestion expands the connotations of the iconography. The icon has been connected with the

Greek expatriate theologian and priest Bessarion (c. 1400–72), who went to Italy for the Council of Florence in 1439, where he argued in favour of the Latin case for the Union of Churches. He converted to Catholicism and was immediately elevated to the position of cardinal. Might this icon, through the anachronism of showing the scholar St Jerome as a cardinal, contain an allusion to Bessarion? Was it the product of a Cretan painter working in Italy?

Whereas the panel of St Jerome shows a Cretan painter skilfully combining eastern and western visual elements into a new form of composite art, which extends the nature of both Renaissance painting and Byzantine art, another icon in the collection shows the more traditional treatment of Byzantine art on Crete. This is the large panel of St John the Baptist in the desert (fig. 59). It is painted over two separate pieces of wood fixed together with wooden pegs, and in the course of its history has suffered some damage.

The panel has been cut down in size; it is now narrower on the right and left than it was originally and the lower parts of the saint's wing on the right are sliced off (the idea of showing the Baptist with wings is first found in the thirteenth century, the intention presumably being to depict him as the messenger sent to earth to prepare the way for Christ). At the bottom the losses are greater. Traces of an inscription on the left show that once there was an invocation from the patron of the icon (now therefore unknown), and probably what is missing from the right is a representation of the severed head of the Baptist. It is nevertheless a strong image, showing the winged St John as a tall thin hermit in the desert being blessed by Christ from heaven. The saint wears a camel-hair tunic beneath his green outer garment and carries a staff topped by a cross. He also holds a scroll with a text known in other Cretan icons, which refers to his sufferings and his martyrdom under Herod. The rawness of the suffering portrayed in this panel makes it very different from the almost aristocratic representation in the Museum's fourteenth-century icon of St John the Baptist (see fig. 36). There are a number of Cretan icons from the late fifteenth and sixteenth centuries which offer parallels for the style and iconography of this panel. It is close to the work of Michael Damaskinos in the second half of the sixteenth century, and gives a clear idea of the character of the traditional production of icon painters at that time.

65. Icon with Christ Pantocrator

Russian, eighteenth century.
112 x 82.8 cm
British Museum

Another significant Cretan icon was purchased in Florence in 1857 and entered the National Gallery's collection. It represents the two most famous doctor saints (they took no fees), Cosmas and Damian, blessed by a figure of Christ in heaven (fig. 60). This icon fits well into the last period of Cretan painting in the seventeenth century: it is ornamental, with decorated haloes, and shows a high level of technical virtuosity. It carries the signature of Emmanuel Tzanes (1610–90), a well-documented artist who, after the fall of Candia to the Turks in 1669, went to the Ionian islands and Venice. Although this panel fits in with his other works, the Tzanes signature is actually a historical snag. Recent research has made it clear that this is most probably a forgery (as are several other signed panels by this artist). This is a complication of the study of Cretan art. Owing to the popularity of this production before the twentieth century and the prevalence of known artists, several panels do have fake inscriptions, including some on works connected with Angelos in the fifteenth century. The addition of an inscription at a later date does not necessarily invalidate an attribution to the named artist, but it adds a measure of doubt.

A small triptych in the collection with the Koimesis between saints has many features of Cretan art at the end of the sixteenth century (fig. 61). But the shape of the panel and the woodcarving of the frame suggest that it was made for use at a monastery on Mount Athos. Theophanes the Cretan is documented as working on Athos in the sixteenth century, and so this triptych provides evidence of the success of Cretan artists not only in Crete and Italy but also in the monastic strongholds of the Orthodox tradition in Greece. The Museum also holds a later panel from Greece with a Koimesis, which alters some of the traditional iconography and responds to ideas from the west (fig. 62). Another icon from the Greek world outside Crete represents the twenty-four stanzas of the Akathistos Hymn (fig. 63). This is a hymn often attributed to Romanos the Melode (its language fits into the early sixth century) in which each stanza is cleverly linked by alphabetic acrostic; it was recited annually in the Orthodox church during Lent. First developed as a pictorial cycle in the fourteenth century, it is here used as the subject of an ornate little framed icon. When it was purchased in Greece in 1917, the icon was said to be from the island of Santorini. The subject was used in both Greece and Russia, and this icon was most likely painted on a Greek island in the late seventeenth or eighteenth century.

These icons offer good evidence of the many functions which the painters could handle. The Athonite triptych could operate as a small folding portable icon for use in the liturgy or private devotions, whereas the Baptist and Cosmas and Damian panels seem destined for display as major icons in a church. The Akathistos Hymn icon might be suitable for private prayer, each tiny picture being an aide-memoire for the poetic text. Exploring functions explains many of the features required by viewers wanting precious and refined aids to prayer and devotions.

RUSSIA

The range of functions of the Russian icons in the collection shows that viewers in the Russian world held similar interests to those in Crete and elsewhere in the Orthodox world. Whether or not the 'Black George' (see fig. 51) is connected with the art of Pskov seems a less pressing issue than to determine its function. It is a major church picture, effective in its environment for projecting the charisma and powers of the saint. Another example to consider is the pair of icons which formed the upper part of the central doors of an iconostasis (the 'Royal Doors'; fig. 64). These seem to date from the seventeenth century and perhaps come from Moscow. Most importantly they let us view the imagery of the Annunciation, one of the common scenes depicted in that part of the church which represented the symbolic passage from earth to heaven. Also probably from a church screen is an icon of Christ in Glory (fig. 65). Other icons in the Museum correspond to another type, the so-called *Vita*, in which a famous saint is represented at the centre of the panel surrounded by episodes from their life as a frame; examples of these include the icons with St Nicholas (fig. 66) and St Cyril Belozerski (fig. 67; now missing its frame).

Particularly important for Orthodox viewers were paintings which conveyed the beauty and sacredness of Mary, the Mother of God and the ideal model of motherhood. For this reason an icon

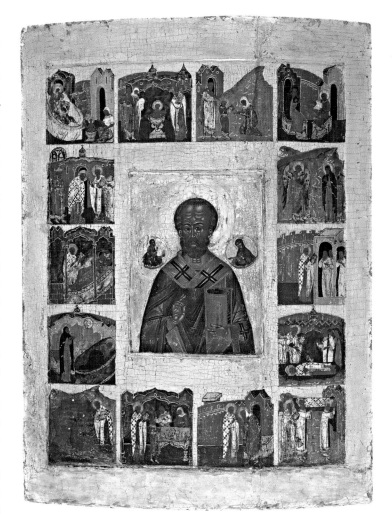

66. Icon with St Nicholas surrounded by fourteen scenes from his life

Russian (north-eastern region), late sixteenth–early seventeenth century (frame); nineteenth century (central insert). 71 x 56 cm
British Museum

of the Kazan Mother of God attributed to the seventeenth century is informative about Russian taste (fig. 68). The small painting is in tempera and framed by a *basma oklad* with precious inlays. The expressions of the Virgin and Child are muted and the style of painting clear and linear, features it shares with many other icons of this type. The 'Kazan-skaya' is the most famous icon type after the Virgin of Vladimir, and its history has many variations. In 1579 the Mother of God appeared in dreams to a young girl in the city of Kazan, east of Moscow, and told her where to uncover her miraculous icon. Several miracles followed its discovery and the icon was installed in Kazan cathedral. It was displayed by soldiers during the liberation of Moscow from the Poles in 1612 and was said

**67. Icon with
St Cyril Belozerski**

Northern Russian,
late sixteenth century
(with nineteenth-
century restoration).
28.5 x 23.2 cm
British Museum

to be with the troops fighting Napoleon in 1812. The original icon therefore had a polit-
ical function in protecting the Russian State in times of national danger, but it was equally
an icon suitable for private prayers and devotion. There are many stories too about its
disappearance: perhaps it was lost in a fire or perhaps it was stolen and taken to the west.
On 28 August 2004, at the initiative of Pope John Paul II, the version of the icon of Kazan
that was in the possession of the Vatican was returned to the Patriarch of Moscow as a
gesture of unity between the Orthodox and Catholic churches. This event and its sym-
bolism was an extraordinary tribute to the many functions of Orthodox icons and their
continuing powers.

At the beginning of this book the question was posed of how the icon fits into modern perceptions: is it art or is it different from art? Now it is surely clear that icons are so inclusive in their functions that this question is scarcely relevant. Through their artistic beauty they work more effectively as sacred objects. They reside in this world, but open the eyes of believers to another level, aiding meditation and faith. At the same time the ways in which they perform this function are legitimate subjects of research.

In 2002 the Archbishop of Canterbury, Rowan Williams, published a book entitled *Ponder These Things. Praying with Icons of the Virgin*. In it he discusses his own way of viewing icons with reference to the Annunciation in the British Museum's collection:

> Sometimes Good Friday falls on 25 March, Lady Day, when we commemorate the Annunciation. Those generations who knew these legends about Mary at her spinning wheel will not have missed the strongest echo of all: the veil of the temple being torn in half as Jesus gives his cry from the cross, the sign that he has once and for all passed beyond the veil, as the letter to the Hebrews says, and lives for ever in the sanctuary of heaven. Because he has torn the veil, we can enter with him; we live in the heavenly sanctuary, offering prayer with him. That is what is happening at every eucharist. So just as Mary is interrupted as she spins the curtain, the whole history of the world is interrupted by the cry of Jesus from the cross: all we try to put between ourselves and God is torn down by God's own utterance.

This reading of an icon is entirely in unison with the writings of churchmen from early Christianity onwards. It sees allusion and reference in every bit of the icon, just as Photios did in 867 when speaking about the new mosaic of the Virgin and Child in St Sophia, describing the details he saw in his mind's eye rather than in the mosaic as we see it now:

> A virgin mother carrying in her pure arms, for the common salvation of our kind, the common Creator reclining as an infant – that great and ineffable mystery of the Dispensation! A virgin mother, with a virgin's and mother's gaze, dividing in indivisible form her temperament between both capacities, yet belittling neither by its incompleteness. With such exactitude has the art of painting, which is a reflection of inspiration from above, set up a lifelike imitation. For, as it were, she fondly turns her eyes on her begotten Child in the affection of her heart, yet assumes the expression of a detached and imperturbable mood at the passionless and wondrous nature of her offspring, and composes her gaze accordingly. You might think her not incapable of speaking, even if one were to ask her, 'How did you give birth and yet remain

68. Icon with the Mother of God Kazanskaya, with silver-gilt and enamelled revetment

Russian, seventeenth century. 33 x 26.5 cm
British Museum

a virgin?'. To such an extent have the lips been made flesh by the colours, that they appear to be merely pressed together and stilled as in the mysteries, yet their silence is not at all inert neither is the fairness of her form derivatory, but rather it is the real archetype.

For the evocative sermon it makes no difference to the speaker or the audience whether an icon dates from the ninth, or the fourteenth, or the seventeenth century, nor do its style or quality matter: the same vein of meditation is equally possible. In a sense all icons look alike to the sermon writer, whereas for the art historian every icon is different and every detail needs careful consideration. This book was written on the premise that all icons do not look the same, yet the Patriarch Photios and the Archbishop Williams show how the devout viewer scarcely sees surface details at all. For instance the Virgin in the Annunciation discussed here is actually represented spinning the thread, not weaving the veil. But Williams is correct that the informed viewer can (or could once) expect to pick up just this reference. Equally, in the apse mosaic of St Sophia the Virgin Mary does not turn her eyes towards Christ, nor does the child recline in her arms like an infant.

In the history of the icon it is not the case either that the church fully controlled the painter or that the painter worked free from restraints. Both the producers and the viewers of icons were part of the same religious world, which saw references to the Gospels everywhere. The icon is indeed art, but it is also representative of a way of life.

Icons in the British Museum

The first icon to enter the collections of the British Museum did so quite by chance. This was the icon with four church feasts (see fig. 30), one of the major Byzantine pieces in the collection. It arrived in the Department of Manuscripts (now the British Library) in 1851 with a set of Syrian manuscripts which had been purchased in Egypt. Its provenance was recorded as the monastery of St Mary Deipara, near the Natron lakes, which is now known as the church of Sitt Miriyam (St Mary) in the Deir el-Suryan (Monastery of the Syrians) in the Wadi Natrun. The visitor to this church today still finds icons there, but is told that the majority of the manuscripts went in the nineteenth century to Cairo, the Vatican or London. In 1852 the icon (in two parts) was transferred to the Department of Antiquities, and it was finally published by O.M. Dalton in *The Burlington Magazine* in 1909.

It is clear from Dalton's article that he thought Byzantine icons were very rare, especially before the fourteenth century. His opinions weigh heavily on the minds of successors who might be considering the icon as an important area of medieval production:

Most of the oldest, those which may date from before the sack of Constantinople in A.D. 1204, are preserved in Italy and Russia: as far as present experience goes, Mount Athos is disappointing in this respect, and has apparently few important secrets to reveal. It is true that many pictures in the monasteries of the Holy Mountain cannot be properly examined, but it was the opinion of [the Russian art historian] Kondakoff,

after the most careful inspection which it was possible for him to make, that very few indeed could claim as early a date as the fourteenth century, and that the existence of anything older than this was problematical. The great majority proved to be lifeless productions of the period between the sixteenth and eighteenth centuries, *œuvres de piété* rather than works of art, and quite half of them appear to have been by ikon-painters from Macedonia, Serbia, Bulgaria, Moldavia, or Russia. As in the case of mural mosaics and paintings, Mount Athos has enjoyed too fabulous a reputation as a treasure house of Byzantine art; the real merit of these monasteries is to have preserved traditions and survivals; in their wonderful interiors we find everywhere the shadow rather than the substance.

Dalton's critical assessment in 1909 of the history of the icon must now be described as severely dated. But it is still widely believed, although our knowledge of the field has changed. We know today, unlike Dalton, that the monastery of St Catherine's at Sinai has preserved hundreds of Byzantine icons of great quality which date as far back as the sixth century. A key exhibition held in Thessaloniki in 1997, *Treasures of Mount Athos*, overturned the view that there were virtually no important Byzantine or later icons in the monasteries of Athos: there are in fact many. But the fact remains that the majority of icons (and this is true of the British Museum collection) date from after the fall of Constantinople and the Byzantine empire in 1453, and that at first sight they seem to represent the 'Byzantine tradition' rather than a living and developing art form.

After the arrival in the Museum of the icon with four church feasts, the next icons to enter the collection, some time later, were gifts rather than purchases. In 1895 the seventeenth-century Russian icon of the Mother of God of Kazan with enamelled silver revetments entered the Museum (see fig. 68), but its story was much less dramatic than that of the arrival of another Russian icon a generation later. This was a version of the Virgin and Child in the iconographic type known as the Vladimir Virgin, in which the Virgin holds the infant Christ to her cheek (see the frontispiece). The original Vladimir icon was sent from Constantinople to Kiev in the twelfth century and from there it was taken first to Vladimir and then finally to Moscow, where it is to be found today in the Tretyakov Gallery. The British Museum version dates from the seventeenth century, and has the following provenance written on its back:

Given to T.A. Kilby, Inland Water Transport Tug Gopher on July 28th 1919 by the monks of the Lake Onega monastery, North Russia, in gratitude for his help in rescuing them and their belongings from the Bolshevists who burnt the monastery.

After this brush with a major historical event of the twentieth century, the icon was given to the Museum in 1924 by Captain H.W. Murray.

In the 1980s the Museum added several important icons to its collections. Before then there were just six icons in the Museum's possession, and only the Byzantine icon with four church feasts – not in good condition – was regarded as being of top quality. In 1983 a bequest of five icons came from James Cockburn Batley, and the fourteenth-century Byzantine icon of St Peter was bought on the market (see fig. 17). In 1984 the thirteenth-century Crusader icon of St George was purchased (see fig. 41), followed in 1986 by the fourteenth-century Byzantine icon of St John the Baptist (see fig. 36). That same year the large early Russian icon of St George and the Dragon, known as the 'Black George', entered the collection. This had been found in North Russia in 1959 and was subsequently cleaned and exhibited in the Tretyakov Gallery in Moscow in 1964–5. Then in 1988 the Museum acquired the very special fourteenth-century Triumph of Orthodoxy icon (see fig. 1).

The emerging high profile of the icon collection, enhanced by a bequest by Guy Holford Dixon JP of seven icons, including the sixteenth-century triptych with the Koimesis and saints, probably painted at Mount Athos (see fig. 61), stimulated the next milestone. This was the decision made by the National Gallery in 1994 to transfer to the British Museum its accumulated holdings of icons. Notable among these were a number painted on Crete, including the icon of St Jerome, which had belonged to John Ruskin and was given to the National Gallery in 1924 by Alfred de Pass (see fig. 53).

The British Museum's holdings of painted icons now amounts to around a hundred objects, presented on the following pages, and in addition it is able to show a number of loans. This book has explored ways of looking at these icons, re-evaluating the importance of the medium a century after Dalton. To place Dalton's views in context, it is worth noting that in 1860 the director of the museum, Anthony Panizzi, was asked by a Select Committee at Westminster: 'You have also, I imagine, Byzantine, Oriental, Mexican and Peruvian antiquities stowed away in the basement?', to which he replied 'Yes, a few of them; and, I may well add, that I do not think it any great loss that they are not better placed than they are'. Things – thankfully – have changed.

Catalogue of the Icons in the British Museum
Compiled by Christopher Entwistle

1. Icon with four church feasts from the Gospels: the Annunciation, the Nativity, the Baptism and the Transfiguration

Byzantine, *c.* 1310–20. 38 x 25.6 cm

1852.1-2.1

Brought with Syriac manuscripts from the monastery of St Mary Deipara near the Natron lakes in Egypt. Transferred from the Department of Manuscripts, British Library, in January 1852

2. Icon with the Mother of God Kazanskaya, with silver-gilt and enamelled revetment

Russian, seventeenth century. 33 x 26.5 cm

1895.12-24.1

Purchased from the Revd W.D. Parish in 1895

3. Icon with the Mother of God Vladimirskaya

Russian, seventeenth century. 31.4 x 25.1 cm

1924.11-1.1

Given by Capt. H.W. Murray in 1924

4. Icon with the Resurrection and Anastasis (Descent into Hell) surrounded by sixteen festival scenes

Russian (Palekh), early nineteenth century. 36.4 x 29.2 cm

1926.11-15.1

Purchased from Comdr. Boris Averkieff in 1926

5. Icon with the Anastasis (Descent into Hell) surrounded by twelve festival scenes

Russian, mid-eighteenth century. 32.4 x 27.4 cm

1960.11-2.1

Given by L.A. Angus-Butterworth through the National Art Collections Fund in 1960

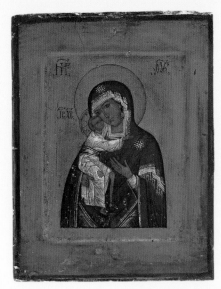

6. Icon with the Mother of God Feodorovskaya

Russian (?Mstera), late nineteenth–early twentieth century. 22.6 x 17.5 cm

1960.11-2.2

Given by L.A. Angus-Butterworth through the National Art Collections Fund in 1960

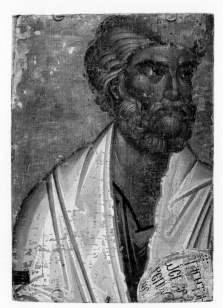

7. Icon with St Peter

Byzantine (Constantinople), early fourteenth century. 68.7 x 50.6 cm

1983.4-1.1

Purchased from Stavros Mihalarias in 1983

8. Icon with St Mark the Evangelist

Northern Russian (Karelia), second half of the seventeenth century. 58 x 38 cm

1983.4-2.1

Bequeathed by James Cockburn Batley in 1983

9. Icon with St Nicholas surrounded by fourteen scenes from his life

Russian (north-eastern region), late sixteenth–early seventeenth century (frame); nineteenth century (central insert). 71.8 x 56 cm

1983.4-2.2

Bequeathed by James Cockburn Batley in 1983

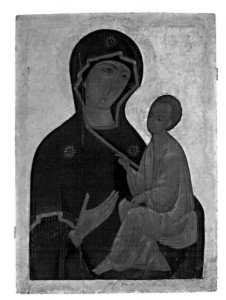

10. Icon with the Mother of God Tikhvinskaya

Russian, eighteenth century. 89 x 66.7 cm

1983.4-2.3

Bequeathed by James Cockburn Batley in 1983

11. Icon with the Resurrection and Anastasis (Descent into Hell) surrounded by twelve festival scenes

Russian, eighteenth century. 32 x 27 cm

1983.4-2.4

Bequeathed by James Cockburn Batley in 1983

12. Icon with the Fiery Ascent of the Prophet Elijah

Russian (Yaroslavl), early nineteenth century. 53.4 x 44.9 cm

1983.4-2.5

Bequeathed by James Cockburn Batley in 1983

13. Icon with
St George and
the Youth of
Mytilene

French artist working
in the Levant, mid-
thirteenth century.
26.8 x 18.8 cm

1984.6-1.1

Purchased from Fine
Art Conservation Ltd
in 1984

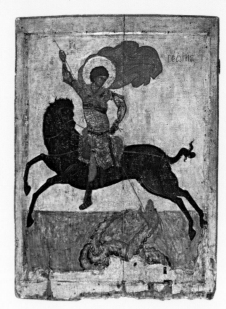

14. Icon with St George
slaying the dragon
(known as the 'Black
George')

Russian (?Northern
Novgorod province),
late fourteenth
century. 77.4 x 57.4 cm

1986.6-3.1

Purchased from Axia
Art Consultants in 1986

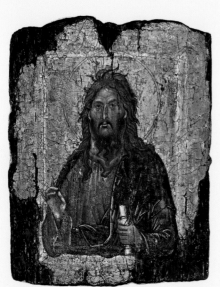

15. Icon with the
Prodromos (St John
the Baptist)

Byzantine
(Constantinople),
c. 1300. 25.1 x 20.2 cm

1986.7-8.1

Purchased from Fine
Art Conservation Ltd
with the help of the
National Art
Collections Fund,
British Museum
Publications and
Stavros Niarchos
in 1986

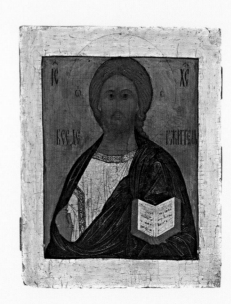

16. Icon with Christ
Vsederzitel

Russian (?Mstera),
late nineteenth–early
twentieth century.
28.1 x 22.2 cm

1986.12-1.1

Given by Mrs Norma
Batley in 1986

17. Icon with the Nativity of Christ

Russian, sixteenth century. 64.4 x 49.4 cm

1986.12-1.2

Given by Mrs Norma Batley in 1986

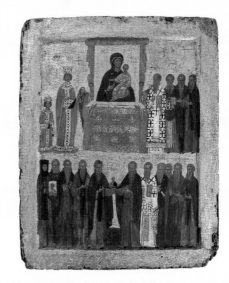

18. Icon with the Triumph of Orthodoxy

Byzantine (Constantinople), *c.* 1400. 39 x 31 cm

1988.4-11.1

Purchased from Axia Art Consultants with the help of the National Art Collections Fund in 1988

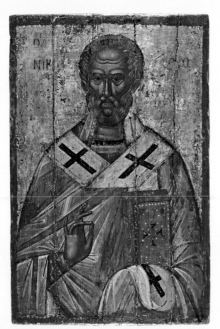

19. Icon with St Nicholas

Greek, sixteenth century. 85 x 55.5 cm

1994.1-2.1

Bequeathed by Guy Holford Dixon in 1994

20. Triptych with the Koimesis (the Dormition of the Virgin) in the centre, flanked by St George, St John Chrysostom and St John Prodromos (left panel), and St Demetrios, St John the Theologian and St Basil (right panel)

Greek (?Mount Athos), late sixteenth century. 17.5 x 13 cm (centre panel); 13.8 x 6.4 cm (left-hand panel); 14 x 6.5 cm (right-hand panel); 26 cm wide when open

1994.1-2.2

Bequeathed by Guy Holford Dixon in 1994

21. Icon with St Nicholas of Mozhaisk with scenes from his life

Russian, seventeenth–eighteenth century. 91.5 x 77.9 cm

1994.1-2.3

Bequeathed by Guy Holford Dixon in 1994

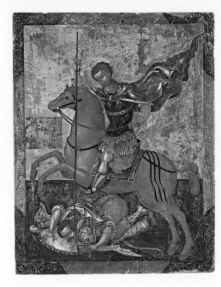

22. Icon with St Demetrios slaying Maxineus, King of the Infidels

Venetian, ?seventeenth century. 51.6 x 40.8 cm

1994.1-2.4

Bequeathed by Guy Holford Dixon in 1994

23. Icon with twenty-five scenes from the Akathistos Hymn

Greek Islands, late seventeenth–eighteenth century. 57.8 x 39 cm (including frame)

1994.1-2.5

Bequeathed by Guy Holford Dixon in 1994

24. Icon with the Madonna della Consolazione

Cretan, seventeenth century. 35 x 27.5 cm

1994.1-2.6

Bequeathed by Guy Holford Dixon in 1994

25. Icon with the First Council of Nicaea and the Forty Martyrs of Sebaste

Greek, eighteenth century. 32.3 x 24.4 cm

1994.1-2.7

Bequeathed by Guy Holford Dixon in 1994

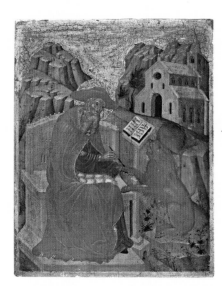

26. Icon with St Jerome

Cretan, fifteenth century. 34.5 x 27 cm

1994.5-1.1

Given in 1920 by Alfred de Pass to the National Gallery, which in turn donated it to the British Museum in 1994

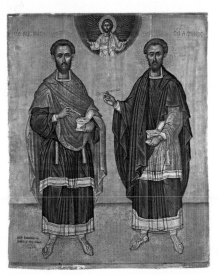

27. Icon with Sts Cosmas and Damian

Cretan, seventeenth century (signed in Greek 'Emmanuel Tzanes' [1636–91], but the signature probably a spurious addition). 67.5 x 55 cm

1994.5-1.2

Purchased from the Lombardi-Baldi Collection, Florence, in 1857 by the National Gallery, which donated it to the British Museum in 1994

28. Icon with the Noli me Tangere (Touch me not)

Cretan, seventeenth century. 63 x 47 cm

1994.5-1.3

Given in 1924 by Mrs C.C. Boys-Smith to the National Gallery, which in turn donated it to the British Museum in 1994

29. Icon with the Koimesis (Dormition of the Virgin)

Greek, seventeenth century. 44.5 x 70.7 cm

1994.5-1.4

Bequeathed by Claude Phillips to the National Gallery, which donated it to the British Museum in 1994

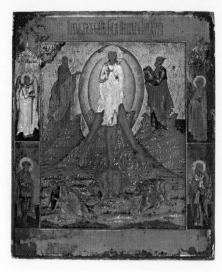

30. Icon with the Transfiguration

Russian (?Nizhnij Novgorod), mid-nineteenth century. 31.5 x 26.2 cm

1994.5-1.5

Purchased in 1926 by the National Gallery, which donated it to the British Museum in 1994

31. Icon (left-hand wing of a triptych) with St Nicholas and St George slaying the dragon

Cretan, sixteenth century. 21 x 10 cm

1995.9-3.1

Purchased from Leila Ashton through the British Museum Friends in 1995

32. Icon with the Mother of God Eleousa ('compassionate') or Glykophilousa ('tender')

Greek (?Mount Athos), seventeenth century. 20 x 14 cm (without frame)

1996.11-3.1

Given by Mrs J.A. Nicholson in 1996

33. Icon with the Mother of God Korsunskaya

Russian (?Moscow), late seventeenth–early eighteenth century. 31.5 x 26.6 cm

1998.6-5.1

Bequeathed by Sir Frank Kenyon Roberts in 1998

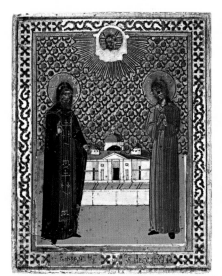

34. Icon with Sts Ephrem Novotorzskij and Arkadij, with an icon of the Mandylion above

Russian, second half of the nineteenth century. 13.5 x 10.7 cm

1998.6-5.2

Bequeathed by Sir Frank Kenyon Roberts in 1998

35. Icon with the Transfiguration

Russian (?Mstera), nineteenth century. 9.9 x 8.5 cm

1998.6-5.3

Bequeathed by Sir Frank Kenyon Roberts in 1998

36. Icon with St Nicholas

Russian (?Moscow), sixteenth century (with nineteenth-century restoration). 29.1 x 23.2 cm

1998.6-5.4

Bequeathed by Sir Frank Kenyon Roberts in 1998

37. Icon with Tsarevich Dimitri and Prince Roman of Uglich, with silver revetment

Russian (?Moscow), seventeenth century (with nineteenth-century restoration). 31 x 25.8 cm

1998.6-5.5

Bequeathed by Sir Frank Kenyon Roberts in 1998

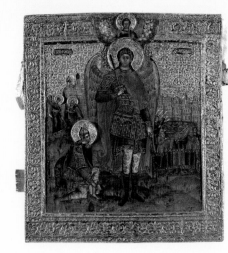

38. Icon with the Miracle of the Apparition of the Archangel Michael to Joshua and to the monk Archippos at Khona

Russian (Moscow), late seventeenth century. 31.8 x 28.5 cm

1998.6-5.6

Bequeathed by Sir Frank Kenyon Roberts in 1998

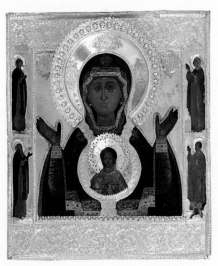

39. Icon with the Mother of God of the Sign, with silver revetment

Russian (Moscow), c. 1838. 31.5 x 26.8 cm

1998.6-5.7

Bequeathed by Sir Frank Kenyon Roberts in 1998

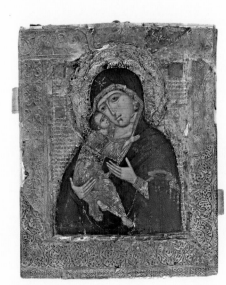

40. Icon with the Mother of God Vladimirskaya, with silver revetment

Russian (?Moscow), nineteenth century. 31.8 x 25.7 cm

1998.6-5.8

Bequeathed by Sir Frank Kenyon Roberts in 1998

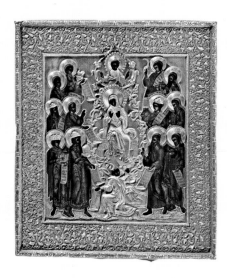

41. Icon with the Eulogy to the Mother of God (Pokhvala Presvyatui Bogoroditsui), with silver-gilt revetment

Russian (?Mstera), seventeenth century (under nineteenth-century restoration). 31.4 x 27.1 cm

1998.6-5.9

Bequeathed by Sir Frank Kenyon Roberts in 1998

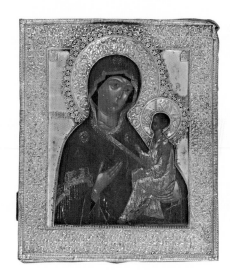

42. Icon with the Mother of God Tikhvinskaya, with metal revetment

Russian, eighteenth century. 36.4 x 31.1 cm

1998.6-5.10

Bequeathed by Sir Frank Kenyon Roberts in 1998

43. Icon with St Prince Theodore of Yaroslavl and his sons David and Constantine

Russian (Yaroslavl), 1650–1700 (with nineteenth-century restoration). 31.7 x 26.5 cm

1998.6-5.11

Bequeathed by Sir Frank Kenyon Roberts in 1998

44. Icon with St John the Evangelist and his scribe Prochoros at Patmos

Russian, seventeenth century (with nineteenth-century restoration). 32 x 26 cm

1998.6-5.12

Bequeathed by Sir Frank Kenyon Roberts in 1998

45. Icon with the Birth of the Virgin Mary surrounded by scenes from the lives of Joachim and Anna

Russian (Palekh), *c*. 1800–50. 36 x 31 cm

1998.6-5.13

Bequeathed by Sir Frank Kenyon Roberts in 1998

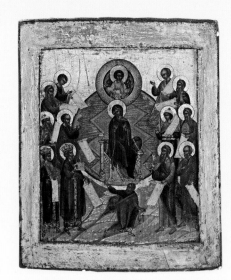

46. Icon with the Eulogy to the Mother of God (Pokhvala Presvyatui Bogoroditsui)

Russian, late seventeenth–early eighteenth century (under nineteenth-century restoration). 31.4 x 26.1 cm

1998.6-5.14

Bequeathed by Sir Frank Kenyon Roberts in 1998

47. Icon with the Miracle of Tikhvin (the appearance of the Mother of God)

Northern Russian, seventeenth century (with nineteenth-century restoration). 31 x 24 cm

1998.6-5.15

Bequeathed by Sir Frank Kenyon Roberts in 1998

48. Icon with St George and the dragon

Russian, eighteenth century. 40.4 x 35 cm

1998.6-5.16

Bequeathed by Sir Frank Kenyon Roberts in 1998

49. Icon with Christ Pantocrator

Russian (?Moscow), late sixteenth–seventeenth century (with nineteenth-century restoration). 28.5 x 24.2 cm

1998.6-5.17

Bequeathed by Sir Frank Kenyon Roberts in 1998

50. Portable triptych with three scenes: the Women at the Tomb (left); the Presentation of the Virgin Mary in the Temple (centre); and the Transfiguration (right)

Northern Russian, seventeenth century (in later metal frame). 10.1 x 8.7 cm (each panel)

1998.6-5.18

Bequeathed by Sir Frank Kenyon Roberts in 1998

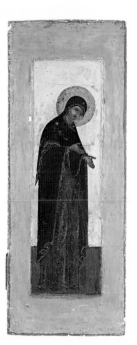

51. Icon with the Mother of God

Russian, eighteenth century. 35.7 x 14 cm

1998.6-5.19.a

Bequeathed by Sir Frank Kenyon Roberts in 1998

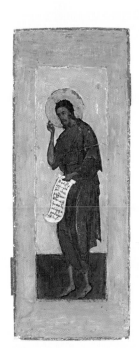

52. Icon with St John the Baptist

Russian, eighteenth century. 35.6 x 14.1 cm

1998.6-5.19.b

Bequeathed by Sir Frank Kenyon Roberts in 1998

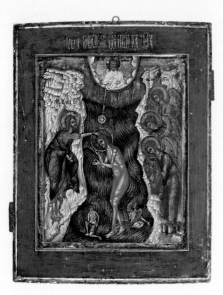

53. Icon with the
Baptism of Christ

Russian (?Mstera),
early nineteenth
century. 44 x 35 cm

1998.6-5.20

Bequeathed by
Sir Frank Kenyon
Roberts in 1998

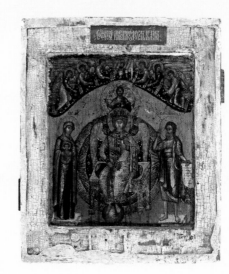

54. Icon with
St Sophia (the
Divine Wisdom)

Russian (?Novgorod),
seventeenth century.
31.5 x 26.5 cm

1998.6-5.21

Bequeathed by
Sir Frank Kenyon
Roberts in 1998

55. Icon with the Koimesis of the Virgin Mary

Russian, twentieth century. 9.1 x 13.5 cm

1998.6-5.22

Bequeathed by Sir Frank Kenyon Roberts in 1998

56. Icon with the
Entry into Jerusalem

Russian (?Moscow),
second half of the
seventeenth century
(with nineteenth-
century restoration).
42.5 x 34.5 cm

1998.6-5.23

Bequeathed by
Sir Frank Kenyon
Roberts in 1998

57. Icon with the Archangel Michael

Russian (Mstera), late nineteenth–early twentieth century (in the style of the seventeenth century). 31.2 x 25 cm

1998.6-5.24

Bequeathed by Sir Frank Kenyon Roberts in 1998

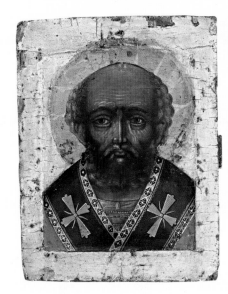

58. Icon with St Nicholas

Russian (?Vologda), late eighteenth century. 22.7 x 17.8 cm

1998.6-5.25

Bequeathed by Sir Frank Kenyon Roberts in 1998

59. Icon with the Anastasis (Descent into Hell)

Russian (Mstera), late nineteenth century. 31.8 x 26.2 cm

1998.6-5.26

Bequeathed by Sir Frank Kenyon Roberts in 1998

60. Icon with the Lamentation/ Entombment

Northern Russian, second half of the eighteenth century. 51.5 x 44.2 cm

1998.6-5.28

Bequeathed by Sir Frank Kenyon Roberts in 1998

61. Icon with Christ
Pantocrator Smolensky

Russian (?Mstera),
end of the eighteenth
century (after 1783).
31.5 x 26.7 cm

1998.6-5.29

Bequeathed by
Sir Frank Kenyon
Roberts in 1998

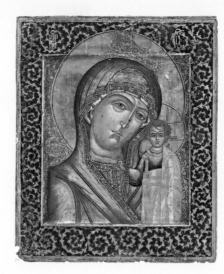

62. Icon with the
Mother of God
Kazanskaya

Russian (?Yaroslavl),
late eighteenth–early
nineteenth century.
34 x 28.6 cm

1998.6-5.30

Bequeathed by
Sir Frank Kenyon
Roberts in 1998

63. Icon with
Sts Zosima and
Savvatiy (founders
of the Solovetsky
Monastery on the
White Sea) holding a
model of a church

Northern Russian,
second half of the
eighteenth century.
31 x 26.3 cm

1998.6-5.31

Bequeathed by
Sir Frank Kenyon
Roberts in 1998

64. Icon with
St Boniface and
sixteen scenes
from his life

Russian (Mstera),
first half of the
nineteenth century.
35.6 x 30.5 cm

1998.6-5.32

Bequeathed by
Sir Frank Kenyon
Roberts in 1998

65. Icon with the Mother of God Vladimirskaya

Russian, late eighteenth century (under nineteenth-century over-painting). 31 x 27.5 cm

1998.6-5.33

Bequeathed by Sir Frank Kenyon Roberts in 1998

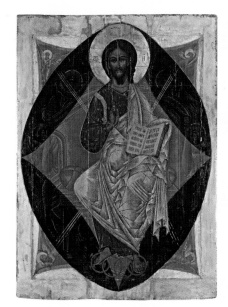

66. Icon with Christ Pantocrator

Russian, eighteenth century. 112 x 82.8 cm

1998.6-5.34

Bequeathed by Sir Frank Kenyon Roberts in 1998

67. Icon with the Resurrection of Christ and the Anastasis (Descent into Hell)

Russian (Moscow), early seventeenth century. 35.7 x 30 cm

1998.6-5.35

Bequeathed by Sir Frank Kenyon Roberts in 1998

68. Icon with the Mother of God of the Sign

Russian, eighteenth century. 30.9 x 26.9 cm

1998.6-5.36

Bequeathed by Sir Frank Kenyon Roberts in 1998

69. Icon with the
Mother of God
(from a Deesis)

Northern Russian,
first half of the
seventeenth century.
84.5 x 32 cm

1998.6-5.37

Bequeathed by
Sir Frank Kenyon
Roberts in 1998

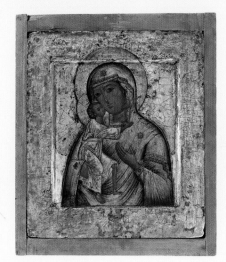

70. Icon with the
Mother of God
Feodorovskaya

Russian (Moscow),
seventeenth century
(with nineteenth-
century restoration).
26.5 x 23.5 cm

1998.6-5.38

Bequeathed by
Sir Frank Kenyon
Roberts in 1998

71. Icon with the
Beheading of
St John the Baptist

Russian (?Yaroslavl),
end of the
seventeenth century.
32.3 x 26.7 cm

1998.6-5.39

Bequeathed by
Sir Frank Kenyon
Roberts in 1998

72. Icon with
St Nicholas the
Wonder Worker

Russian (Kholui),
first half of the
nineteenth century.
37.7 x 31.2 cm

1998.6-5.40

Bequeathed by
Sir Frank Kenyon
Roberts in 1998

73. Icon with
St Dimitri of
Thessaloniki

Russian (Mstera),
nineteenth century.
31.2 x 26.5 cm

1998.6-5.41

Bequeathed by
Sir Frank Kenyon
Roberts in 1998

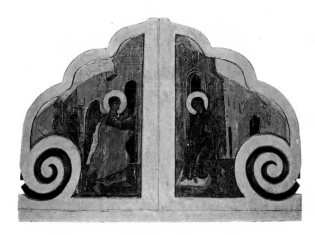

74. Upper part of a Royal Door with the
Annunciation to the Virgin

Northern Russian, early seventeenth century. 58.5 x 87 cm

1998.6-5.42
Bequeathed by Sir Frank Kenyon Roberts in 1998

75. Icon with a
Guardian Angel,
the Ascension and
selected family saints

Russian (Kholui), mid-
nineteenth century.
26.5 x 22.2 cm

1998.6-5.44

Bequeathed by
Sir Frank Kenyon
Roberts in 1998

76. Icon with St Basil
the Great, St Peter
and Sts Xenia,
Matrona and Natalia

Russian (St
Petersburg), mid-
eighteenth century.
31 x 26.6 cm

1998.6-5.45

Bequeathed by
Sir Frank Kenyon
Roberts in 1998

77. Icon with St Nicholas surrounded by various saints and festivals

Northern Russian, second half of the seventeenth century. 31.2 x 27.5 cm

1998.11-4.1

Given by Mrs Norma Batley in 1998

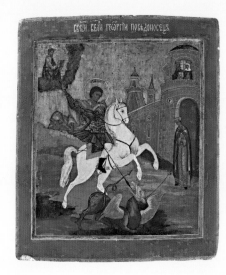

78. Icon with St George slaying the dragon

Russian, mid-nineteenth century. 30.8 x 26.6 cm

1998.11-4.2

Given by Mrs Norma Batley in 1998

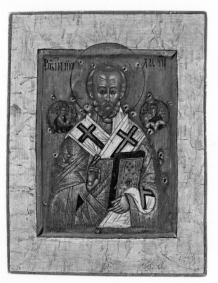

79. Icon with St Nicholas the Wonder Worker

Russian (?Kholui), late nineteenth century (with twentieth-century restoration). 22.2 x 17.5 cm

1998.11-4.3

Given by Mrs Norma Batley in 1998

80. Icon with the Koimesis (Dormition of the Virgin)

Byzantine, fourteenth century. 15.4 x 10.7 cm

1998.11-5.1

Given by Miss Ella Wentworth Dyne Steel in 1998

81. Icon with the Annunciation to the Virgin

Cretan, seventeenth century. 30.3 x 24.8 cm

1998.11-5.2

Given by Miss Ella Wentworth Dyne Steel in 1998

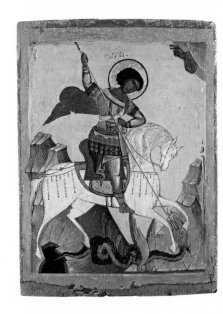

82. Icon with St George slaying the dragon

Russian (Novgorod), early sixteenth century. 65 x 49.4 cm

1998.11-5.3

Given by Miss Ella Wentworth Dyne Steel in 1998

83. Icon with St Paraskeva-Pyatnitsa

Russian (mid Volga region), early seventeenth century. 45.2 x 36.6 cm

1998.11-5.4

Given by Miss Ella Wentworth Dyne Steel in 1998

84. Icon with the Mother of God Vladimirskaya

Russian, nineteenth century. 30.8 x 26 cm

1998.11-5.5

Given by Miss Ella Wentworth Dyne Steel in 1998

85. Icon with
St Nicholas

Russian (Mstera),
seventeenth century
(with extensive
nineteenth-century
restoration). 32 x 26.2 cm

1998.11-5.6

Given by Miss Ella
Wentworth Dyne
Steel in 1998

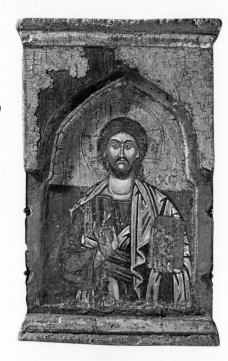

86. Icon with the
half-length figure
of Christ

Greek, seventeenth
century. 18.3 x 11.1 cm

1998.11-5.7

Given by Miss Ella
Wentworth Dyne
Steel in 1998

87. Icon with
St Athanasius
and St Demetrios
slaying the infidel

Greek, seventeenth
century. 24 x 9.5 cm
(without frame)

1998.11-5.9

Given by Miss Ella
Wentworth Dyne
Steel in 1998

88. Icon with
St Athanasius
and St George
slaying the dragon

Greek, seventeenth
century. 22 x 9 cm
(without frame)

1998.11-5.8

Given by Miss Ella
Wentworth Dyne
Steel in 1998

89. Icon with St Spyridon

Greek, eighteenth century. 14.5 x 13.9 cm

1998.11-5.10

Given by Miss Ella Wentworth Dyne Steel in 1998

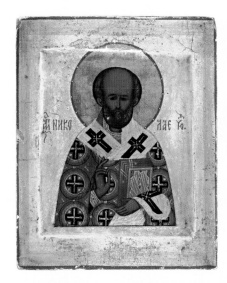

90. Icon with St Nicholas the Wonder Worker

Russian (Mstera), late nineteenth century. 13.3 x 11.2 cm

1998.11-5.11

Given by Miss Ella Wentworth Dyne Steel in 1998

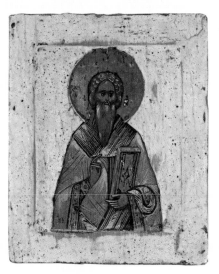

91. Icon with ?St Basil the Great (part of a triptych with nos. 92 and 93)

Russian, nineteenth century. 7.5 x 6 cm

1998.11-5.12

Given by Miss Ella Wentworth Dyne Steel in 1998

92. Icon with Christ Pantocrator

Russian, nineteenth century. 7.5 x 6 cm

1998.11-5.13

Given by Miss Ella Wentworth Dyne Steel in 1998

93. Icon with
?St Blaise

Russian, nineteenth
century. 7.5 x 6 cm

1998.11-5.14

Given by Miss Ella
Wentworth Dyne
Steel in 1998

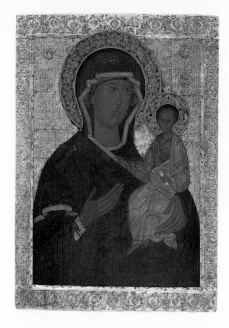

94. Icon with the
Virgin Hodegetria,
with silver-gilt and
enamelled revetment

Russian, sixteenth
century. 74 x 52 cm

1998.11-5.27

Given by Miss Ella
Wentworth Dyne
Steel in 1998

95. Icon (triptych) with the Holy Trinity and saints

Greek, nineteenth century. 25.5 x 18 cm (closed);
35.2 cm wide when open

1922.10-13.1

Given by Private J.H. Crabbe, Royal Army Service Corps, in 1922

96. Icon with the
Fiery Ascent of the
Prophet Elijah

Russian (Mstera), early
nineteenth century.
30.5 x 24.7 cm

1944.10-1.59

Given by Miss M.H.
Turner in 1944

97. Icon with
St John the Baptist

Cretan, sixteenth
century. 89 x 64 cm

2000.11-6.1

Bequeathed by
Miss Ella Wentworth
Dyne Steel in 2000

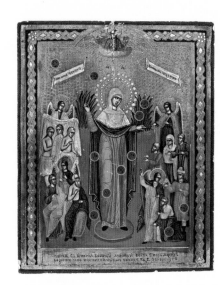

98. Icon with the
Mother of God, 'Joy
to All who Grieve'

Russian (?Kholui),
late nineteenth or
early twentieth
century. 22 x 18 cm

1993.12-1.1

Given by HM
Customs and Excise
in 1993

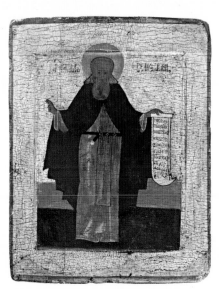

99. Icon with
St Cyril Belozerski

Northern Russian,
late sixteenth
century (with
nineteenth-century
restoration).
28.5 x 23.2 cm

2002.11-1.1

Bequeathed by
Miss Ella Wentworth
Dyne Steel in 2002

100. Icon with the
New Testament
Trinity

Russian (Kholui), late
nineteenth century.
28.3 x 21 cm

1920.11-18.1

Given by Howard
Carter in 1920

BIBLIOGRAPHY

The spellings of names and terms used in this book conform with those in Alexander P. Kazhdan (ed.), *The Oxford Dictionary of Byzantium*, New York and Oxford, 1991.

Several of the icons discussed are described in the following exhibition catalogues

Abel, Ulf, with Vera Moore, *Icons*, Nationalmuseum, Stockholm, 2002.

Buckton, David (ed.), *Byzantium. Treasures of Byzantine Art and Culture*, British Museum, London, 1994.

Drandaki, Anastasia (ed.), *Pilgrimage to Sinai. Treasures from the Holy Monastery of Saint Catherine*, Benaki Museum, Athens, 2004.

Evans, Helen C., and William D. Wixom (eds), *The Glory of Byzantium. Art and Culture of the Middle Byzantine Era A.D. 843–1261*, Metropolitan Museum of Art, New York, 1997.

Evans, Helen C. (ed.), *Byzantium. Faith and Power (1261–1557)*, Metropolitan Museum of Art, New York, 2004.

Nelson, Robert S., and Kristen M. Collins (eds), *Holy Image, Hallowed Ground. Icons from Sinai*, J. Paul Getty Museum, Los Angeles, 2006.

Tradigo, Alfredo, *Icons and Saints of the Eastern Orthodox Church*, J. Paul Getty Museum, Los Angeles, 2006.

Vassilaki, Maria, *Mother of God. Representations of the Virgin in Byzantine Art*, Benaki Museum, Athens, 2000.

Icons feature in a number of surveys of Orthodox art

Belting, Hans, *Likeness and Presence. A History of the Image before the Era of Art*, Chicago, 1994.

Cormack, Robin, *Painting the Soul. Icons, Death Masks and Shrouds*, London, 1997.

Cormack, Robin, *Byzantine Art*, Oxford, 2000.

Coomler, David, *The Icon Handbook. A Guide to Understanding Icons and the Liturgy, Symbols and Practices of the Russian Orthodox Church*, Springfield, IL, 1995.

Gerstel, Sharon E.J. (ed.), *Thresholds of the Sacred, Architectural, Art Historical, Liturgical, and Theological Perspectives on Religious Screens, East and West*, Washington, DC, 2006.

Jensen, Robin M., *Understanding Early Christian Art*, London, 2000.

Loverance, Rowena, *Byzantium*, London, 1988–2004.

Manafis, Konstantinos A. (ed.), *Sinai. The Treasures of the Monastery of Saint Catherine*, Athens, 1990.

Mango, Cyril, *The Art of the Byzantine Empire 312–1453*, Englewood Cliffs, NJ, 1972 (an excellent selection of primary texts translated into English).

Ousterhout, Robert, and Leslie Brubaker (eds), *The Sacred Image East and West*, Urbana and Chicago, 1995.

Safran, Linda (ed.), *Heaven on Earth. Art and the Church in Byzantium*, University Park, PA, 1998.

Tarasov, Oleg, *Icon and Devotion. Sacred Spaces in Imperial Russia*, London, 2002.

CHAPTER 1
Icons and iconoclasm. The power of images

Baltoyianni, Chrysanthe, *Icons. Mother of God*, Athens, 1994.

Barber, Charles, *Figure and Likeness. On the Limits of Representation in Byzantine Iconoclasm*, Princeton, 2002.

Beard, Mary, 'Reflections on "Reflections on the Greek Revolution"', *Archaeological Review from Cambridge*, 4:2 (1985), pp. 207–13.

Brubaker, Leslie, and John Haldon, *Byzantium in the Iconoclast Era (ca 680–850): The Sources. An Annotated Survey*, Aldershot, 2001.

Chatzidakis, Nano, *Icons. The Velimezis Collection*, Athens, 1998, pp. 86–91, no. 5.

Evans, Helen C. (ed.), *Byzantium. Faith and Power (1261–1557)*, Metropolitan Museum of Art, New York, 2004, pp. 154–5, no. 78.

Freedberg, David, *The Power of Images*, Chicago, 1989.

Hyman, John, *The objective eye: Colour, Form, and Reality in the Theory of Art*, Oxford, 2006, p. 3.

Mango, Cyril, 'Antique Statuary and the Byzantine Beholder', *Dumbarton Oaks Papers* 17 (1963), pp. 55–75, esp. p. 66.

Nikephoros Kallistos, son of Xanthopoulos, in J.P. Migne, *Patrologia Graeca*, col. 173 (quoted in James D. Breckenridge, *The Numismatic Iconography of Justinian II*, New York, 1959, esp. pp. 58–9).

Pentcheva, Bissera V., *Icons and Power. The Mother of God in Byzantium*, University Park, PA, 2006.

St Germanos of Constantinople, *On the Divine Liturgy*, Greek text with translation, introduction and commentary by Paul Meyendorff, Crestwood, NY, 1984.

St John of Damascus, *On the Divine Images. Three Apologies Against Those Who Attack the Divine Images*, translated by David Anderson, Crestwood, NY, 1980, esp. pp. 17–18 (First Apology) and pp. 52–3, sections 5 and 7.

CHAPTER 2
How to make an icon

Bank, Alicia, *Byzantine Art in the Collections of the USSR*, Leningrad and Moscow, 1966, nos 273–5.

Clavijo, Ruy Gonzáles de, *The Embassy to Tamerlaine 1403–1406*, translated from the Spanish with an introduction by Guy le Strange, London, 1928, p. 84.

Cutler, Anthony, 'The Industries of Art', in Angeliki E. Laiou (ed.), *The Economic History of Byzantium from the Seventh through the Fifteenth Century*, Washington, DC, 2002, vol. 2, pp. 555–87.

Drandaki, Anastasia, 'Through Pilgrims' Eyes: Mt Sinai in the Pilgrim Narratives of the Thirteenth and Fourteenth Centuries', *Deltion tis Christianikis Etaireias* 27 (2006), pp. 491–504.

Durand, Jannic, 'Precious-Metal Icon Revetments', in Helen Evans (ed.), *Byzantium. Faith and Power (1261–1557)*, Metropolitan Museum of Art, New York, 2004, pp. 243–51.

Evans, Helen C. (ed.), *Byzantium. Faith and Power (1261–1557)*, Metropolitan Museum of Art, New York, 2004, pp. 192–3, no. 112.

Hetherington, Paul, The 'Painter's Manual' of Dionysius of Fourna, London, 1974.

Jolkkonen, Nina, et al. (eds), Icon Conservation in Europe, seminar at Frankfurt am Main 24–28 February 1999, published by the Valamo Art Conservation Institute, Finland, 1999. See esp. Ivan Bentschev, 'The Varnished Icon: A Historical Study of Varnishes', pp. 64–8.

Kroesen, Justin, and Regnerus Steensma, The Interior of the Medieval Village Church, Leuven, 2004.

Labrecque-Pervouchine, Nathalie, L'Iconostase. Une évolution historique en Russie, Montreal, 1982.

Mango, Cyril, The Art of the Byzantine Empire 312–1453, Englewood Cliffs, NJ, 1972, p. 42.

Martin, Linette, Sacred Doorways. A Beginner's Guide to Icons, Brewster, MA, 2002, p. 46.

Mihalarias, Stavros, and Robin Cormack, The Icon of St Peter, London, 1985.

Muñoz Viñas, Salvador, 'Original written sources for the history of Mediaeval painting techniques and materials: a list of published texts', Studies in conservation 43 (1998), pp. 114–24.

Oikonomides, Nicolas, 'The Holy Icon as an Asset', Dumbarton Oaks Papers 45 (1991), pp. 35–44.

Oikonomides, Nicolas (ed.), Actes de Dochareiou, Paris, 1984, no. 49.

Ousterhout, Robert, The Art of the Kariye Camii, London, 2002.

Ramos-Poqui, Guillem, The Technique of Icon Painting, Tunbridge Wells, 1990.

Teteriatnikov, Vladimir, Icons and Fakes. Notes on the George R. Hann Collection, New York, 1981.

Thomas, John, and Angela C. Hero (eds), Byzantine Monastic Foundation Documents. A Complete Translation of the Surviving Founders' Typika and Testaments, Washington, DC, 2000, esp. vol. 1, p. 357, and vol. 4, p. 1562.

Underwood, Paul A., The Kariye Djami, New York, 1966.

CHAPTER 3
Reading icons

Buckton, David (ed.), Byzantium. Treasures of Byzantine Art and Culture, British Museum, London, 1994, pp. 73–4, no. 64 (entry by Anthony Eastmond).

Dijk, Ann van, '"Domus Sanctae Dei Genetricis Mariae" – Art and Liturgy in the Oratory of Pope John VII', in S. Kaspersen and E. Thunø, Decorating the Lord's Table. On the Dynamics between Image and Altar in the Middle Ages, Copenhagen, 2006, pp. 13–42, esp. p. 15 for the quotation from St Nicholas of Andida (also published by Hans-Joachim Schultz, The Byzantine Liturgy, New York, 1986, pp. 89–90).

Mango, Cyril, The Homilies of Photius Patriarch of Constantinople. English Translation, Introduction and Commentary, Washington, DC, 1958, esp. Homily XVII, pp. 279–96.

O'Keefe, John J., and R.R. Reno, Sanctified Vision. An Introduction to Early Christian Interpretation of the Bible, Baltimore and London, 2005.

St John Climacus, The Ladder of Divine Ascent, translated by C. Luibheid and N. Russell, London, 1982.

St Nicholas of Andida, 'Protheoria', in J.P. Migne, Patrologia Graeca, col. 417.

CHAPTER 4
Saints

Boas, Adrian J., Crusader Archaeology. The Material Culture of the Latin East, London, 1999.

Bierbrier, Morris L. (ed.), Portraits and Masks. Burial Customs in Roman Egypt, London, 1997.

Buckton, David, 'A Byzantine icon for the British Museum', National Art-Collections Fund Review (1987), p. 85.

Doxiadis, Euphrosyne, The Mysterious Fayum Portraits. Faces from Ancient Egypt, London, 1995.

Flam, Jack, Matisse: the Man and His Art, Ithaca, 1986, p. 323.

Flower, Harriet I., Ancestor Masks and Aristocratic Power in Roman Culture, Oxford, 1999.

Folda, Jaroslav, Crusader Art in the Holy Land, From the Third Crusade to the Fall of Acre, 1187–1291, Cambridge, 2005.

Jacoby, David, 'Society, Culture, and the Arts in Crusader Acre', in Daniel W. Weiss and Lisa Mahoney (eds), France and the Holy Land. Frankish Culture at the End of the Crusades, Baltimore, 2004, pp. 97–137.

Kamil, Jill, Christianity in the Land of the Pharaohs. The Coptic Orthodox Church, London, 2002.

Kühnel, Bianca, Crusader Art of the Twelfth Century, A Geographical, an Historical, or an Art Historical Notion?, Berlin, 1994.

Maguire, Henry, The Icons of their Bodies. Saints and their Images in Byzantium, Princeton, 1996.

Mango, Cyril, The Art of the Byzantine Empire 312–1453, Englewood Cliffs, NJ, 1972, pp. 212–13.

Mathews, Thomas F., 'The Emperor and the Icon', Acta ad archaeologiam et artium historiam pertinentia, 15 (2001), pp. 163–77.

Mathews, Thomas F., and Norman Muller, 'Isis and Mary in early icons', in Maria Vassilaki (ed.), Images of the Mother of God. Perceptions of the Theotokos in Byzantium, Aldershot, 2005, pp. 3–11.

Mouriki, Doula, 'Thirteenth-Century Icon Painting in Cyprus', The Griffon, N.S. 1–2 (1985–6), pp. 9–112.

Papamastorakis, Titos, 'The "Crusader" Icons in the Exhibition', in Anastasia Drandaki (ed.), Pilgrimage to Sinai. Treasures from the Holy Monastery of Saint Catherine, Benaki Museum, Athens, 2004, pp. 46–63.

Sande, Sire, 'Pagan "Pinakes" and Christian Icons. Continuity or Parallelism?', Acta ad archaeologiam et artium historiam pertinentia, 18 (2004), pp. 81–100.

Shore, A.F., Portrait Painting from Roman Egypt, British Museum, London, 1972.

Skalova, Zuzana, and Gawdat Gabra, Icons of the Nile Valley, Giza, 2006.

Sörries, Reiner, Das Malibu-Triptychon, Dettelbach, 2003.

Soteriou, George, and Maria Soteriou, Eikones tes Mones Sina, Athens, 1956 (vol. 1) and 1958 (vol. 2).

Walker, Susan, and Morris Bierbrier, Ancient Faces, British Museum, London, 1997.

Walter, Christopher, The Warrior Saints in Byzantine Art and Tradition, Aldershot, 2003.

Weitzmann, Kurt, The Monastery of Saint Catherine at Mount Sinai. The Icons. Volume One: from the Sixth to the Tenth Century, Princeton, 1976.

Weitzmann, Kurt, Studies in the Arts at Sinai, Princeton, 1982.

The icon with St George slaying the dragon (fig. 51), known as the 'Black George', was studied in 1960 at the I.E. Grabar State Restoration Workshop and a report in the files of the British Museum was written by the restorer A.N. Ovchinnikov. The icon was exhibited at the Tretiakov Gallery in Moscow in 1964–5 and published in S.V. Yamshchikov, Old Russian Painting: recent discoveries (in Russian), Moscow, 1966, pls 6–7, and in A. Ovchinnikov and N. Kishilov, The Painting of Ancient Pskov (also in Russian), Moscow, 1971, no. 16, pl. 33.

CHAPTER 5
Icons after Byzantium

Adey, More, 'An Icon Illustrating a Greek Hymn', *The Burlington Magazine* 34 (1919), pp. 45–55.

Brisbane, Mark, and David Gaimster (eds), *Novgorod: the Archaeology of a Russian Medieval City and its Hinterland*, London, 2001.

Buckton, David (ed.), *Byzantium. Treasures of Byzantine Art and Culture*, British Museum, London, 1994, p. 215, no. 229 (entry by Valika Foundoulaki), and pp. 224–5, no. 237 (entry by Maria Vassilaki).

Chatzidakis, Manolis, *Greek Painters after the Fall of Constantinople (1450–1830)* (in Greek), Athens, 1987 (vol. 1) and 1997 (vol. 2).

Chatzidakis, Nano, *From Candia to Venice. Greek Icons in Italy 15th–16th Centuries* (Venetiae Quasi Alterum Byzantium 2), Athens, 1993.

Constantoudaki-Kitromilides, Maria, 'San Gerolamo con il leone risanato su icone di arte cretese: Il soggetto e il suo significato simbolico' (in Greek with an Italian summary), *Anthi Hariton*, Venice, 1998, pp. 193–216.

Georgopoulou, Maria, *Venice's Mediterranean Colonies: Architecture and Urbanism*, Cambridge, 2001.

Lymberopoulou, Angeliki, 'A winged St John the Baptist icon in the British Museum', *Apollo* (November 2003), pp. 19–24.

Mango, Cyril, *The Art of the Byzantine Empire 312–1453*, Englewood Cliffs, NJ, 1972, p. 187.

Smirnova, Engelina, *Painting of Novgorod the Great. Middle of the 13th to beginning of the 15th century* (in Russian), Moscow, 1976.

Smirnova, Engelina, *Moscow Icons 14th–17th Centuries*, Oxford, 1989.

Williams, Rowan, *Ponder these things. Praying with Icons of the Virgin*, Norwich, 2002.

ACKNOWLEDGEMENTS

It has been my good fortune to be able to work on the British Museum's collection of icons and my research has been enabled by the support of the Director, Neil MacGregor; of David Buckton and Rowena Loverance; and in particular of Christopher Entwistle, who currently curates the icons. The team at the British Museum Press, including Teresa Francis, Rosemary Bradley and Axelle Russo, have been always helpful, and I am grateful to Price Watkins for their design and especially to Felicity Maunder for her eye for detail.

Conservators at the British Museum, especially Lynne Harrison, and at the Getty Museum, especially Tiarna Doherty, have shared their observations with me. I have also learned much over the years from Stavros Mihalarias and Yanni Petsopoulos.

Considerable help and information has been given to me in the monastery of St Catherine at Sinai, Egypt, by Father Justin Sinaites and Father Porphyrios Sinaites under the benevolent care of Archbishop Damianos of Sinai. During visits to the monastery I have benefited from observations made by colleagues and postgraduates of the Courtauld Institute of Art, particularly from Diana Newall and Emma Loveridge. Most of all I have learned from Maria Vassilaki and Stergios Stassino-poulos's great knowledge of icons.

In Greece I must thank various colleagues for their generosity in sending me publications, particularly Nano Chatzidakis, Maria Costantoudaki-Kitromilides, Anastasia Drandaki and Pana-yiotis Vokotopoulos. My deep thanks to Angelos Delivorrias, Director of the Benaki Museum, Athens, for allowing me to work with the resources there. I have also been helped in icon research by Michele Bacci, Gerhard Wolf, Alexei Lidov and Sharon Gerstel. Helen Evans at the Metropoli-tan Museum of Art, New York, has been generous with knowledge and all sorts of help. Antony Eastmond, Liz James and Jas Elsner have given me many ideas too.

I was able to complete this research through my tenure of a Leverhulme Emeritus Fellowship at the Courtauld Institute of Art and I am indebted to this support, particularly for travel. I was also able to participate in the scholar programme at the Getty Research Institute at Los Angeles with its remarkable resources, and would like to thank especially Tom Crow and Charles Salas.

I have relied on many other people too, but no one more than Mary Beard.

ILLUSTRATION REFERENCES

Photographs © The Trustees of the British Museum, Department of Photography and Imaging, unless otherwise stated. References are British Museum registration numbers.

Page

Page	Reference
1, 6, 12, 13	1988.4-11.1
2	1924.11-1.1
8	Photo author
9	© Tom Lubbock
10	1998.6-5.31
11	State Historical Museum, Moscow
15	Velimezis Icons Collection, Athens
16	Benaki Museum, Athens; inv. 11296
17	1998.11-5.27
19	akg-images / Erich Lessing
21	Left: 1986.5-11.1; centre: Michel no. 458; right: 1856.4-25.11
23	By permission of the British Library, London; Add. MS 43725, folio 247
24	© Ancient Art & Architecture Collection Ltd
27	Elis 72
28	1852.9-23.875
30, 42	1983.4-1.1
33	1998.6-5.25
34	1998.6-5.7
37, 38	Gaspare Fossati, *Aya Sofya Constantinople, as Recently Restored by Order of H.M. the Sultan Abdul Medjid*, London, 1852, pls 25 and 3.
39	Photo author
41	Adapted from Leonid Ouspensky, *The Theology of the Icon*, St Vladimir's Seminary Press, 1992, vol. 2, fig. 34, p. 273.
44, 45	Stavros Mihalarias
46	OA 9999
48	akg-images / Erich Lessing
51	1904.7-2.1
53, 58, 60	1852.1-2.1
54	Photo author
57	Photo © Held Collection / The Bridgeman Art Library
59	V&A Images / Victoria and Albert Museum
62	1986.7-8.1
65, 66	EA 21810
68	Photo author
69	1926.4-9.1
70, 71, 72–3, 76 (left)	1984.6-1.1
74	Bibliothèque nationale de France
75	Photograph by Bruce White. © 2003 The Metropolitan Museum of Art
76 (right)	Photograph by Bruce White. © 2003 The Metropolitan Museum of Art
77	Photo author
78	Photo author
79	Photograph by Bruce White. © 2003 The Metropolitan Museum of Art
82	1986.6-3.1
84	1998.6-5.16
86	1994.5-1.1
88	1994.1-2.6
89	1994.5-1.3
91	© 1990 Photo Scala, Florence
92	1998.11-5.3
93	© 1990 Photo Scala, Florence
95	2000.11-6.1
96	1994.5-1.2
98	1994.1-2.2
99	1994.5-1.4
101	1994.1-2.5
102	1998.6-5.42
103	1998.6-5.34
105	1983.4-2.2
106	2002.11-1.1
108	1895.12-24.1

INDEX